BEING AND NEONNESS

BEING

& NEONNESS

LUIS DE MIRANDA

translated by Michael Wells

translation and content revised, augmented, and updated for this edition by Luis de Miranda

THE MIT PRESS
CAMBRIDGE, MASSACHUSETTS
LONDON, ENGLAND

This book was set in Arnhem Pro and Helvetica Rounded by The MIT Press.

Library of Congress Cataloging-in-Publication Data

Names: Miranda, Luis de, 1971- author.
Title: Being and neonness / Luis de Miranda ; translated by Michael Wells, translation and content revised, augmented, and updated for this edition by Luis de Miranda.
Other titles: L'être et le néon. English
Description: Cambridge, MA : The MIT Press, [2019] | Translation and content revised, augmented, and updated for this edition of: L'être et le néon (Luis de Miranda, Max Milo, 2012). | Includes bibliographical references.
Identifiers: LCCN 2018038345 | ISBN 9780262039888 (hardcover : alk. paper) ISBN 9780262551984 (paperback)
Subjects: LCSH: Existential phenomenology. | Light—Symbolic aspects. | Color (Philosophy) | Neon lighting—History.
Classification: LCC B818.5 .M5713 2019 | DDC 150.19/2—dc23 LC record available at https://lccn.loc.gov/2018038345

I turned my collar to the cold and damp
When my eyes were stabbed by the flash of a neon light
That split the night
And touched the sound of silence
—Simon and Garfunkel, "The Sound of Silence"

CONTENTS

To breathe Paris preserves the soul.
—Victor Hugo[1]

PRELUDE: ONCE UPON A TIME IN THE CITY OF LIGHT

When we hear the word *neon*, an image pops into our heads: a combination of light, colors, symbols, and glass. This image is itself a mood. It carries an atmosphere. It speaks, still confusedly, of the essence of cities, of the poetry of nights, of the twentieth century. Neon signs might seem to be silent, anecdotal objects at the back of our minds, about which there can be nothing to say—glittering tautologies, *a neon is a neon*. But, as a pipe is not a pipe, a neon is much more than a neon. Neon signs can be more than nostalgic symbols floating between periods, not yet belonging to the postmodern digital era, yet already beyond modernism. Very few of us have looked at neon signs with enough concentration, patience, and philosophical curiosity. Modern philosophers, from Descartes to Bachelard, enjoyed gazing into a fire to conduct their meditations on the nature of being and consciousness. In this book, we will contemplate neon lights.

Invented in Paris a century ago, neon signs not only encapsulate gas within glass but also are a time capsule sent to us from before the First World War, before Europe lost its progressist

innocence. Since then, they have witnessed all the transformations that have created the world we live in. Today, they sometimes seem to maintain a hybrid status, somewhere between junkyards and museums, not unlike European capitals themselves. But let's forget nothingness for a little while: *neonness* has fresher ideas to whisper into our ears, ideas about who we were, are, and are becoming. Neon has not been here for eons, yet diving into the sea of hidden impressions it fosters will give us a sense of the evolution of our global identities. This is a book about neon lights; this is a book about you.

One winter evening, I was ambling along the river between the Louvre and the Pont Neuf, on my way to the Latin Quarter. All of a sudden and out of the (red and) blue, I stopped in front of a large sign in neon letters advertising a little kebab joint. The rosy halo of the words was framed in a cryogenic blue and cut through the night like a supernatural tattoo:

FAST-FOOD
CREPES-KEBAB
PIZZA
COFFEE-TEA-CAKE

I was standing in one of the oldest districts of Paris. The buildings all around were hundreds of years old. Under my feet, archaeologists could surely find the bones of medieval corpses.

But this source of anachronistic, reddish light showed no concern for its cultural environment. It is there, at number 28 Quai du Louvre, glowing day and night. This rectangle of hyperrealist fire that I shall call *the trigger neon* encapsulates

condensed globalized food in a mere eight words, mixing fast-food America with the France of crepes, the Middle East of kebabs, Italy's pizzas, Asian tea, and English cake. Clinically overlit, it seemed blithely unaware of the shock of civilizations, but very concerned with the daily flow of tourists trailing in dazzlement through the City of Light.

On that evening, I realized that up until that moment, I had no longer noticed neon signs. Nonetheless, they are still ubiquitous, although people regularly predict their disappearance and replacement by light-emitting diodes (LEDs). Neon lights are considered a part of the "charm" of cities around the world, manifesting their metropolitan DNA. As I stopped to gaze at this trigger light in the shadow of the Louvre, I felt that something was trying to get out, that a riddle was seeking to be solved. And so, quite unexpectedly, without forethought or calculation, I started this investigation, which my mind immediately baptized *L'Être et le Néon* in French, a title that echoes naturally Jean-Paul Sartre's classic, *L'Être et le Néant* (*Being and Nothingness*).

Paris invented the neon light. The first fluorescent shop sign in history appeared on a Parisian boulevard in 1912. At that time, the City of Light was still perhaps the beating heart of the West. The lines written by poet Heinrich Heine about Paris nearly a century before still rang somewhat true: "All is here assembled which is great by love or hate, by feeling or thought, by knowledge or ability, by fortune or adversity, by the future or the past. ... A new art, a new religion, a new life is here created, and the creators of a new world are here in joyous action together."[2] In 1912, when the avant-gardists Apollinaire, Duchamp, Tzara, and Breton were wandering the streets of Paris looking for intellectual adventures, a barber's shop sign, the first instance of a global contagion, suddenly lit them up at 14 Boulevard

Montmartre where—is it by chance?—the neon Open sign of the Hard Rock Café shines today. As the First World War was in gestation, the strange light of the little Palais Coiffeur hairdressing shop caught the gaze of the passers-by, doubled the barber's turnover, and then went on to transform the nighttime face of the planet in a few short decades. Yet there was hardly anything to it: a glass tube, a little rare gas, a zest of electricity. But it was "new"—*neos* in ancient Greek.

A century after the first neon appeared, many say that the Western world, Europe in particular, is moribund and that a city like Paris has been mummified. They put forward various arguments pointing to the decline of Europe, the move eastwards of economic growth, the impoverishment of the middle classes, aging populations, imagination at half-mast, the clannish corruption of the ruling elites, exorbitant rents, the commodification of leisure, institutional and cultural conservatism, the return of nationalism and the pace of immigration, the exodus of youth and talent, the inaccessible luxury of the city center and soulless suburbs, streets emptied and turned into Disneyfied museums patrolled by the police, the diktats of European regulations ... all disputable evidence to argue that social creation, carefree audacity, intelligent adventure, and the discovery of possible worlds are no longer so easy within the city limits. Duchamp, Tzara, Apollinaire, and Breton would have a harder time fulfilling their reckless destiny today.

Tourism, on the other hand, is doing well. "Nowadays Paris is perhaps the world's best-known brand after Coca-Cola," as the architect Bertrand Lemoine put it in 2010 when he was appointed director of the Atelier international du Grand Paris, a political public interest group for the Greater Paris area, the purpose of which is to extend the conurbation and harmonize it with the

suburbs. This comparison with the hegemonic American soda is of course worrying, especially coming from a specialist whose role is to help shape our future environment. We should not underestimate the fantasy of transforming Paris into a sweetened bubble, the perfect gondola-end offer for travel agents, one that would guarantee a syrupy simulacrum of intoxication. Will the City of Light be transmogrified into an open-air shopping center? Has Paris become one gigantic neon sign lit up by the obsession to sell herself to her forty million annual visitors?

In 1995, the rap group Assassin brought out *Touche d'Espoir* (Touch of hope), an album with a track on it called "Paris Théorie": "Writers, Assassins, Metaphysicians, we don't just hit with our fists, ... the style of Paris, it's precise, straight up, survival, shining, demonstrating ... , in the city where I live my enemies sleep, too. Let's repel their tyranny, apply the theory of Paris, not your lethargy." What if we were to take this invocation of a mysterious theory of Paris seriously? Has there not been an *idea* of Paris, a certain ideal of freedom and utopia that has navigated the centuries and has never been drowned, whose avatars we may still discover today, transmigrated in different regions of the world?

It is not a coincidence that neon signs were invented in Paris rather than in Las Vegas. The Paris I have in mind is not the somewhat aggressive and chaotic capital of today; it is an older idea, now largely emigrated from the geographical Paris itself, a fragile yet enduring spirit that spread around the world, much as neon signs did. The playwright Sacha Guitry said that "to be Parisian, is not about being Parisian by birth, but about being born again there." Until the 1970s and since the seventeenth century, the capital was a place where human or artistic freedoms materialized, a place of the future. In the nineteenth century, from Balzac to Baudelaire, taking in "utopianists" along

the way such as Proudhon, Charles Fourier, the feminist Jeanne Deroin, or the idealist Théodore Dézamy, there was a certain zest to use the term *realization* to mean "render an idea real"—a type of creation that I have elsewhere called *crealization*. In his *Salon de 1846*, Charles Baudelaire also talks of "realizing the idea of the future," but the tone he uses to address the bourgeoisie is a mixture of lucidity and sarcasm: "You have gone into business together, set up companies, taken out loans to realize the future in all its diverse forms, whether political, industrial or artistic. You have never ceded the initiative in whatever noble enterprise to the suffering, protesting minority, which also happens to be the natural enemy of art."[3] One hundred and fifty years later, with Assassin's song "Paris Théorie," the tone of address to the bourgeoisie has lost its irony: "Given your economy that exploits my people like in the USA, you vote for self-made men to avoid the problem, Misery, a gangrene that you treat only if you love." Indeed, if we allow an unloving minority to produce the reality that surrounds and carries us economically, culturally, and psychologically, we might end up in a world of global misery.

Paris—as an idea that can be found also in New York, Stockholm, Hong Kong, Rio de Janeiro, or Bissau—has long held the ambiguous promise of a political and aesthetic space in which everyone could exist rather than just survive, could play out their destinies rather than suffer serfdom. Yet our global capitals have become a contradiction; many of their inhabitants do not truly prosper, yet wear the appearance of well-being, the mask of standard happiness and the apparel of liberty. Cities of commercial luxury with strong class divides, our urban territories are a flashing light, blinking between being and neon, seduction and pose, pride and hypocrisy. Nations inspired by the French Revolution have spent two hundred years demanding Liberty but

have never really been so sure about wanting Equality and Fraternity, two abstract values that for many people make a messy mixture that threatens the order of things.

Our cities are a paradox; they have become standardized laissez-faire zones where the creation of value is seen primarily in financial terms, but where we still also breathe the aspirational scent of a more harmonious Elsewhere, where we hum the refrain, between two careerist business appointments, of a song for political justice: a tune to inspire conversations and sometimes elections, but not always real human transactions. As the 1950s approached, following the shadow of the war and German occupation, Jean-Paul Sartre already described Paris as the international capital of bad faith, describing the cafés where *believing is not believing*, as he put it in *Being and Nothingness*. The gatekeeper of French existentialism added that to radically escape from bad faith, the corrupted individual has to take control of himself, an act which, under the influence of Danish philosopher Søren Kierkegaard, Sartre called *authenticity*, a term that in our times of doubt some like to pronounce with grimacing reservations.

What would an *authentic* urban existence be? Authenticity, related to authorship, is the state of creating—that is, the conviction that being in the world is an incessant generation or perpetuation of realities, including when we feign to believe that we can create nothing, but simply reproduce archetypes. Bad faith is for Sartre a certain idea of realism whereby you have to adapt to the world as it is and submit, albeit cunningly, to the established "order of things." Being practically and constantly aware of our natural creativity is difficult, but it takes perhaps even more effort and pain to make sure that nothing changes and that the slogans of reality maintain their mantras day and night like neon signs!

It's not easy to be a generous self in the city, to create and share new codes independently of the domineering neon signs. Let's take an *authentic* Parisian metaphor. One evening, a man turns down the offer of a seductive woman to make love in public—they are embracing in the middle of a picturesque pedestrian street near the Champ-de-Mars and the Eiffel Tower, in front of a café terrace sprinkled with observers. Is she, in good faith, saying take me, here and now, on the tarmac, in front of witnesses? No, this is just an existential provocation; she feels that copulating in the lamplight, watched by others, is beyond the scope of this bashful man. She teases him with a touch of haughty amusement: "You're a prisoner of the realm of seeing."

Which human being today is not dominated by the power of looks and insensitive to the gaze of others, even if through screens and avatars? It's a commonplace to say that appearance and dress rule over us, that visual imperative and superficial effect take precedent over a more intimate, freer attention to the unseen. Many are worried about what people might observe. Our contemporary world, wrote Sartre, believes that it can reduce existence to the series of appearances it makes manifest. But can it, really? Couldn't we deliberately close our eyes to become Pythagorean *acousmaticians*, guided by hearing and sonic vibrations rather than sight or touch? One of the aims of this book is to suggest that we relearn how to listen, beyond the realm of seeing.

All through the second half of the twentieth century, we dreamed of the year 2000. As children we often saw the future as a desirable destination where any metamorphosis was possible, a paradise peopled with fairylike mutations and luminous gadgets. But as we grew up, we started to feel, day after day, rightly or wrongly, that the future was late in arriving, that

it was—and is—always now as *future*, and therefore never here as *present*. New habits are slow in forming. Our conservatism clutches on to protocol more stickily than glue to labels. And sometimes, unsettled, we stroll the streets under the neon halos as if nothing really new, nothing momentous, nothing unheard of might ever happen to us, as if the façades of buildings were made of papier-mâché, social rituals forged in bronze and human behavior mass-produced.

Mystics call this solitude of the estranged wanderer the *Experience of Nothingness*, in which nothing appears to exist for us, all seems vain, and even illusion is illusory. It is an encounter with a vacuum, a passage across the desert, a slate wiped clean, more or less voluntarily. This melancholia or depression sometimes precedes a creative renaissance. I am not alone in believing that the *creal* child within us, the idealistic co-creator of the real, never completely dies, even if sometimes in the throes of death. Surely, the global growth of human freedom is not always that obvious; after all, it took us two hundred years to go from the sale of slaves to the slavery of sales. Today we can even buy "ourselves" back in the form of data. But our noble souls are not dead or digitized yet. There is no time of life during which we cannot refute the defeatism often underpinned by a realistic lexicon.

Neon lighting will be one of the lasting symbols of the twentieth century. Take it as a poststructuralist metaphor if you will, but something inherent in the social relations of domination seems to be both obscured and overexposed by the glamorous light of the fluorescent signs and the fascination they exert. If neon is a metonym, we must discover of what. Street neon is an incessant reminder of the objectification of awareness, an asset in the economy of attention, a mirror of our insectlike obsession with mimetic reflections, but also something more that we need

to explore. At the end of the twentieth century, a French cosmetics brand adopted the injunction *Être Soi-Même*, "to be yourself," as its slogan, drummed in thrice over for the hard of hearing: "Beauty lesson number 1: *to be yourself*. Beauty lesson number 2: *to be yourself*. Beauty lesson number 3: *to be yourself*." Identity in the twentieth century was shaped in neon fashion: an aesthetic crystallization, a daily projection of identical appearance, a self-tautology modeled on appearance rather than truth. And yet we ask: What is the truth of neon?

From the outset, the neon secretions, like so much luminous sap, have flickered between soliciting and entertaining the passing punters, wavering between saturation and magic, bourgeoisie and art. The milky neon halo has conquered the world and perpetuated this ambivalence, from Las Vegas to Hong Kong by way of Nairobi and Teheran. Millions of neon signs, sometimes pallid, sometimes brash, are still significant letters of the global urban alphabet, ever shimmering in the shadows and whispering a ballad about who we still are, who we are not anymore, and who we might become. Every year, millions of tourists and inquisitive souls visit the cities of light in search of an aesthetic, elegant experience, one that combines the upbeat tempo of the unexpected with a hint of bohemianism. And yet today's tourists, if they are honest with themselves, have to admit a certain disappointment, a wistful regret that they were not swept off their feet by the vibrant metropolis they had expected, the illusory reflection of which waves at us from behind the mirror of history, channeling Romantic city strollers, the crazy Roaring Twenties, or postwar existentialism. By now the capital has become, in part at least, a trompe l'oeil.

Should we be less idealistic and throw out, once and for all, our poetic thirst and hope for a better, ever-harmonious existence?

It's up to us. The twenty-first century will offer once again a radical choice to humankind, depending on our idea of the best of possible worlds, between two impossible extremes—perhaps whether we become sleepwalking automata or whether we usher in true, shared freedom. At the time of writing these lines, the word *crisis* shines above our European nights like a blaring hazard warning light. "I belong to the generation without remuneration," sings a recent Portuguese fado tune with contemporary lyrics: "What a stupid world in which one needs to study to become a slave!"[4] In *The Consumer Society: Myths and Structures*, Jean Baudrillard wrote, a little before the end of the thirty-year postwar boom: "Our markets, our commercial thoroughfares, our supermarkets mimic a rediscovered, prodigiously fertile, natural environment. They are for us like the biblical Promised Land of Canaan, where instead of milk and honey, the neon flows over ketchup and plastic."[5] The apogee of the neon era was that maternal time of illusory and manufactured abundance, a hypostasis of the light, the deranged halo of which we scrutinize now, like the faulty screen we might slap to bring the image back.

What are we up to? Will we perpetuate the hyperrealist reign of light, a sanitized society in which everything is aseptic, analyzed, compartmentalized, discrete, soundproof, both real and unreal? Will we joyfully dive into the invisible and plunge into the vibrations of the *chaosmos* (a neologism propelled by James Joyce), this holistic and cosmic creative flow, to gradually orchestrate other orders, as yet unimagined social relations? To be *creal* is to be confident and feel empowered. We are magnets. We want to invent various twenty-first centuries. We will think, create, and live in many worlds. We have confidence in the future, eyes half shut the better to dream, ears pricked up the better to see.

In this world where I engage myself, my actions cause values to spring up like partridges.
—Jean-Paul Sartre[1]

THE LETTER AND THE NEON

When we utter the word *neon*, we should imagine a reddish orange. To get blue, you have to use another gas, argon, sometimes mixed with mercury. For white, we might use krypton, helium for yellow, and hydrogen for red. In common parlance, *neon* signifies any fluorescent light with a milky, sometimes soft, sometimes slightly more aggressive halo. There is often something ghostly about these halos; today, there are cemeteries of neon signs, and this book might be a contribution to their obituary. Yet their longevity might surprise us.

In Boris Vian's 1947 novel, *L'Écume des jours*—literally, "the foam of days"[2]—we discover that a fictional Jean-Sol Partre gave an imaginary lecture entitled "The Letter and the Neon," "a famous critical study on luminous signs." What sort of light will we produce if we mix Vian's poetic music and the real-life Sartre's insights in a slim glass tube? In the months that followed my encounter with the neon trigger on the Quai du Louvre, the disingenuously anodyne character of neonness haunted me to such an extent that it pushed apparently more "serious" ideas to the back of my mind. I started reading *Being and Nothingness*,

the seven-hundred-page slab that contains an entire histori-cal era. A simplified version of existentialism has become the implicit popular philosophy of our times, encapsulated in the ideal of *self-realization.*

From its first sentence, already alluded to, this wordy but touching doorstop of a book brings out the twentieth century's concern with phenomena and appearance: "Modern thought has realized considerable progress by reducing the existent to the series of appearances which manifest it."[3] To *exist* for Sartre refers to the fact of emerging out of a background, getting out of what there is, to stand out. To exist is like an enforceable attempt to escape the flowing materiality or immanence of things, and it requires a twofold effort, like squaring the real, or a "decompression of being," as Sartre put it. Moreover, to exist is to remove oneself from an undifferentiated being and bring out the unheard of, perhaps the incredible—to dare the fostering of a subtler Logos, to articulate a dialectic of sense and nonsense. To exist is to bring to life, in a certain manner, invisible flows of preexistence. Elsewhere, in *Situations*, Sartre wrote that "it is impossible to correctly appreciate light without knowing the darkness," echoing what Victor Hugo wrote in 1867 about the International Exposition and the idea of the City of Light: "Paris is a sower. Where does he sow? In the darkness. What does he sow? Sparks."

In 2009, in the somber stone corridors of the medieval Louvre Palace, a few meters away from the kebab-cake-crepe merchant and our trigger neon, the American artist Joseph Kosuth dis-played in fluorescent letters attached to the old stones sentences in French inspired by the philosophy of Nietzsche—for example: *ni apparence ni illusion* (neither appearance nor illusion). At the time, I found these neon inscriptions rather banal: using the

gaseous light of advertising signs seemed like a commonplace in contemporary art. But Kosuth did contribute to our collective reflection in favoring the encounter not of a sewing machine and an umbrella, but of the underground foundations of medieval Paris and neon signs. I was not aware of these installations when I met the trigger neon outside of the Louvre a few years later, a few meters away. This book might be the inverted image, the other side of the coin of Kosuth's artistic display: I prefer to begin with a prosaic fast-food neon sign, in the wild, rather than with quotes from the history of philosophy in a museum environment.

Yet the history of philosophy is not to be left aside. Since Heidegger, contemporary philosophers have been using the term *ontic* to designate the beingness of determinate objects in the world. By contrast, *ontological* refers to the nature of Being. Along with a conceptual study of neon, this book aims to be a *critique of neontic reason*, an attempt to escape from the stupefying prison of light that encircles objective phenomena. Heidegger, who had an important influence on Sartre, was wondering—at the time that neon started to be seen also in the streets of German cities—whether the oblivion of Being in the West had not reached the point at which it was not distinguished from phenomena, manifest beings. As this book unfolds, we will attempt to project a neontic perspective on the question "What is being?"

In a text from 2006 entitled "Some of the paths leading to contemporary art,"[4] Barbara Puthomme, an artist herself, writes about Joseph Kosuth's neon sculptures, in particular the work called *Five Words in Orange Neon*: "The piece is composed of this utterance written in orange neon letters. Far from being a transparent revelation of something in the realm of truth—which is

how we might schematically describe Heidegger's thesis—the work of art sends back to us an image of itself; it breaks up the traditional conception of art in which the work is supposed to reveal something." Are we to deduce that in the medium of neon, art has found its end, its aporia? Is neon the tautological limit beyond which contemporary beingness no longer unveils itself, where it is no more than a moment of coagulation in the current of reproductive existence, a more or less presentable object in the midst of an arbitrary series of signs? Or should we turn to the work of Dan Flavin—the American artist who became the "high priest of light"[5] following his theological studies in the 1950s—to feel the mystic connections between fluorescent tubes and the stained glass or candles in churches? I believe that behind our fascination for luminous signs trembles our repressed religiousness, our aspiration for an intimate relationship with the creative cosmos. The artificial lights of the night have become a problematic substitute for the constellations.

In 1860, the Goncourt brothers complained in their journal that life in Paris was on the verge of becoming totally *public*—today we would also say *transparent*—since the Baron Haussmann had built his great boulevards sprinkled with café terraces and enticing shop windows. A century later, in 1955, in his *Introduction to a Critique of Urban Geography*, the situationist Guy Debord would consider this consumerist modernism as a perfidious form of "police control," a tragic betrayal as horrible as a Shakespearean crime: "Haussmann's Paris is a city built by an idiot, full of sound and fury, signifying nothing."[6] The sociologist Richard Sennett, influenced among others by the situationists, dates the birth of our entertainment society to the streets of Paris in the second half of the nineteenth century and the concomitant beginning of the obfuscation

of the masses. The bourgeoisie and the workers were more or less subjected to the same treatment of blinding commercialization. With the appearance of nighttime lighting supplied by shop owners, then enhanced from 1912 onward by the arrival of neon, merchandize protected us from obscurity and affected to reassure us. In the twentieth century, controlling light meant controlling society through consumption, and this is still true today through the light of our computer or phone screen. Electric lighting sold stuff. Less unpredictable and profound than real fire, it subdued the household, overexposed behavior, and standardized thought. In his *Practical treatise on advertising*,[7] written a century ago, Désiré Hémet wrote of the flashing luminous signs that "the passer-by is indisposed by a brand which uses and abuses his eyes, obliging them to submit to work they had not consented to." Thus, the charm of our democracies: we are asked to consent to things that make us (feel) stupid, and mental rape becomes institutionalized with our wearied assent. For over one hundred years, advertising photons have been hammering out their brash and frenzied obnubilation. At night, in the deserted city center streets, communal public lighting insidiously mixes with the private advertising signs.

In 1704, Isaac Newton published a study on *Opticks* in which he wrote: "But Light is never known to follow crooked Passages nor to bend into the Shadow." By observing the urban journeys of neon lights, we feel that Newton's truth is relative. Rather, the amoral, fluorescent waves diffract in zigzags through our streets, adopting the most baroque trajectories and tracing ciphers of photons in the air. It seems as if there is something in them that wishes to be set free, that its struggle for emancipation is so intense that it convulses into sparks of light. Sometimes the city looks on the verge of a luminous storming of the Bastille,

a prison of appearances and codes, a chaos of impressions corseted in crystal; one day perhaps, light years from 1789, it will all blow up again.

When his wife Michelle had a dalliance with Sartre under Simone de Beauvoir's benevolent or indifferent eye, Vian, not one for false harmony, went off to live with the dancer Ursula Kübler. They soon found a place to live at 6bis Cité Véron, a few stanzas away from the poet Jacques Prévert. From the next-door building, at number 8, Luneix, a neon-manufacturing company, unfurled its luminous reign across Paris from 1936 to 1965. Among its clients, there were more than two hundred businesses of all sorts: industries, tobacconists, electricians, tailors, cinemas, garages, travel agencies, and many brasseries, cafés, and bistros, as well as some more or less louche hotels. As I wandered around Pigalle a stone's throw from the Cité Véron, I stopped for a minute in front of the sad window of a red-light bar called the *Feeling*, its glaringly indiscreet Franglais sign a snapshot of the neon century, in which affect is rationalized like an identikit profile on a digital dating site. European red-light districts have certainly contributed to the reputation that neon has acquired.

In Paris, the Moulin Rouge area has been one of the temples of neonness. In his little book on luminous signs,[8] historian Philippe Artières quotes a 1927 article published in the *Frankfurter Zeitung* by sociologist Siegfried Kracauer, who wrote, "The neon signs of [Pigalle] are mechanical fires that tremble with venal sensuality. Pyrotechnic flares crossing each other under a canopy, clearly pointing towards the center, to where everything flows, and the wheel of Moulin Rouge turns, but grinds no grain." Throughout the world, bright red neon often became a sign to indicate prostitution. Perhaps the tradition goes back

to the Roman courtesans, who wore red wigs. In the Book of Revelation, the Whore of Babylon, mother of all prostitutes and all earthly vice, is dressed in purple and scarlet. In bullfighting, it is customary to say that the function of red, associated with the shaken muleta, is to excite the beast who is destined to die. As for the alchemical symbol associated with the color of blood, which designates sulfur, it resembles, yet without the half-moon, the symbol for women—a cross under a circle.

In the early twenty-first century, French women's fashion writers, inspired by the English-speaking world, adopted the term *neon* to describe the colors that in the 1980s had been known in French as *fluo*, which in turn became a deprecative synonym for *garish*. In his heartbreaking 1884 short story "The Necklace," Guy de Maupassant shows how much the working or lower middle classes were completely absorbed by the desire to be part of the aristocracy of the moment: "There is nothing more humiliating than to appear poor among rich women," says the unfortunate Mathilde. It is still true today for many. Women's magazines are often hymns to adornment and class greed. The ideally dressed woman (and now girl) mimics the entertainment stars and follows the trend consultants. The French magazine *Elle* announced in 2012: "We like neon colors; the figure is flashy and fun; summer will be pop." *Pop* means *popular* elevated to the rank of glamor and understandable for everyone, lightweight stimuli. Light is light.

Today's good taste is sometimes yesterday's bad taste and vice versa. Neon signs, which were considered rather vulgar at the end of the twentieth century, have in recent years benefited from a nostalgic return to favor. Still, many have forgotten that since their invention and until the end of the 1930s, they were seen as the embodiment of Parisian brilliance and good taste.

In 1927, to mark an international exhibition, the Eiffel Tower was decorated with ten kilometers of blue, green, and pink neon tubes, intended as a display of refinement. In 1919, perhaps to forget the First World War, the façade of the Paris Opera was covered in red and blue neon lights—a rather surprising way of soliciting trade if we remember that the opera's architect, Charles Garnier, already in 1871 did not pull his punches against invasive street posters in the *Gazette des Beaux-Arts*: "For me it is not enough to sweep the streets to avoid stepping in shit. We also should sweep away these invasive signs which plaster my path and spatter my sight." However, the example of the Paris Opera demonstrates that the decoration of public façades with fluorescent tubes was a gesture of refinement in the early 1920s. For a long time afterward, the mixture of neon red and argon blue would be known as "opera color"—the very same as our trigger neon from the Quai du Louvre.

In *Let There Be Neon*,[9] Rudi Stern tells us that neon only arrived in the United States in 1923, more than ten years after the technique had been developed in France by Georges Claude, a self-taught genius. In 1902, Claude, who later described his discovery as being like a "living flame," was one of the founders of Air Liquide, now a multinational industrial gas company, which was established on a patent to liquefy the gases contained in air (oxygen, nitrogen, helium, argon, krypton, xenon, and neon). He spoke with a sensual fervor about protoneons: "The idea of liquefaction under pressure brusquely appears to me, undoubtedly due to a spark lighting up an overexcited brain. I fixed a simple tube, two centimeters in diameter, one meter in length, into the exhaust holder and the other end I closed with a tap, through which I fed part of the compressed, cold air from the holder. Then, trembling with emotion at this supreme moment,

I switched on the machine. After a moment of anxious waiting, the precious liquid started to run. Finally!"[10]

The prehistory of neon is earlier, dating back to 1673, when the French astronomer Jean Picard, the first to make a precise calculation of the earth's radius, observed a light in a mercury barometer, a long tube resembling a giant thermometer. In 1683, Otto von Guericke, mayor of the German town of Magdeburg and inventor of the vacuum pump, successfully produced light from static electricity. Twenty-six years later, English scientist and member of the Royal Society Francis Hauksbee discovered that if he placed a little quantity of mercury in the glass of the electrostatic generator designed by the aforementioned Guericke, then evacuated the air from it and gently rubbed the ball, a light became visible—and it was enough light to read by. In 1744, a friend and librettist of Johann-Sebastian Bach, Johann-Heinrich Winkler, professor of philosophy, Greek, and physics in Leipzig, replicated the experiment and twisted the tube into letters to make a name, the first word traced in light by humankind. Was it the name of his wife? His daughter? God? A mystery to be solved in a few pages.

Sartre wrote in the introduction to *Being and Nothingness*: "If the phenomenon is to reveal itself as *transcendent*, it is necessary that the subject himself transcend the appearance toward the total series of which it is a member. He must seize *Red* through his impression of red. By Red is meant the principle of the series—the electric current through the electrolysis, etc."[11] Sartre explains that a phenomenon is defined by a series of points of view from which we consider it. This series is infinite; at any moment the subject can adopt a new perspective and reveal an aspect of the world. He *realizes* the being of the appearance by *determining* the infinite, *this* electric Red. Sartre adds, "This new

opposition, the 'finite and the infinite,' or better, 'the infinite in the finite,' replaces the dualism of being and appearance. What appears in fact is only an aspect of the object."[12] Is the object, as object, something other than the sum of its aspects? Is there something hidden behind the phenomena, as philosophers have been asking themselves for the past three thousand years, too often spinning out the metaphor of vision and appearance?

Since Socrates, the least dogmatic philosophy holds that the meaning of being is first and foremost about the act of questioning, about the idea in us that things can become other than they appear. This questioning is never neutral, as Nietzsche discovered in the nineteenth century; the philosopher is always a political animal who aims to make the world echo his more or less higher self and to transform his own self into the echo of the cosmos. He or she aims to remain faithful to what makes us the children of infinity. The best thinkers and idealists are more than dialecticians: they are *crealecticians*, creative inspirers in the realization of ideas and ideals. But what is the relation between the power to make things real and neon signs?

Countless social arrangements are designed to regulate the relations between being and seeming.
—Pierre Bourdieu[1]

AUGUSTUS REX

What did Paris look like in 1912, the year that neon signs first appeared? Matisse was painting *Nasturtiums with the Dance*, Gabrielle "Coco" Chanel was setting up shop in the Rue Cambon, the Seine had been flooding as never before, and the *Mona Lisa* had been stolen from the Louvre by Vincenzo Peruggia. At this time, Debussy, Ravel, and Satie were composing the definitive soundtrack of the epoch, compulsory military service lasted three years, the aviator Roland Garros was breaking records in the air in one of the first metal airplanes, and religion was still sufficiently tenacious for the archbishop of Paris to declare that Christians should not dance the tango—an announcement that must have amused the arch-atheist Vladimir Lenin, who was visiting the French capital at the time. In 1912, extracts of what would become *In search of lost time* by the almost unknown Marcel Proust were published in the daily *Le Figaro*, but readers were much more interested in the partial eclipse of the sun visible in April from the heart of the city. Pablo Picasso and Gertrude Stein were exchanging ideas with cubist collages, but the general public had never heard of them and were more taken up with Joseph

Pujol (aka Le Pétomane), a famous professional flatulist. A baby quite like another, the future playwright Jean Anouilh, had just been born. Much later, in 1970, he would write that "nowadays any bistro philosopher, who drinks Coca-Cola, sitting on a plastic stool under a neon light, thinks he knows much more than Plato."

I am sitting in a Parisian bistro with a copy of *Courrier International*, and I think I know not more than Plato, the eon visionary, but I believe we might learn something from the dialectic between neon and eon, as you will see. As I flick through the pages, I happen on an article about the Neon Museum (*Muzeum Neonu*) in Warsaw, Poland: "The photographer Ilona Karwinska undertook the preservation of the old luminous signs which adorned the Polish capital during the Cold War." In the 1960s the Soviets deployed a vast "neonization" of the Eastern bloc capitals to emulate capitalist metropolises. Because consumer shops were rare in the Polish capital, they did not hesitate to illuminate the façades of public buildings, such as the library of the faculty of science. Raoul Vaneigem, author of *A treatise on how to live for the young generations*,[2] wrote at the same time, in the *Internationale Situationniste* journal, "Urban planning and information are equally complementary in capitalist and anti-capitalist societies: they organize the silence" by projecting a "social hierarchy without conflict" into public space. Already in 1921, the aforementioned Lenin had defined communism as a politics of artificial lighting: "Communism = Soviet Power + electrification."[3]

In 1856, in Germany, Heinrich Geissler succeeded in producing a bluish light by using alternating current inside a tube in which he had placed some mercury and created a vacuum. We now know that some gases can conduct electricity and produce light more efficiently than incandescent lamps. Between 1860

and 1890, there were numerous attempts to illuminate city streets in the West at low cost using the principle of electrical discharge. In the 1890s, when Nikola Tesla emigrated to the United States, was it still possible to see the stars above the New York City sky? The Serbian inventor set up his laboratory near Broadway and got involved in a bitter and now infamous dispute with Thomas Edison, who was initially his employer. They debated the respective merits of continuous or alternating currents. In February 1892, when Tesla was participating in a conference in Paris, he bombarded a high-voltage alternating current in tubes filled with phosphorous and curved to form the word *lumière* (light). The demonstration created quite a stir among those present; perhaps Georges Claude, the inventor of street neon, was in the room; he was twenty-two years old at the time and had just finished his studies at the School for Industrial Physics and Chemistry.

The Tesla tubes did not last very long; they quickly went wrong, as the electrodes corroded in contact with the gases. Other inventors attempted to improve the process by using nitrogen or carbon dioxide. In 1897 in England, Sir William Ramsey and Morris W. Travers developed a technique to isolate rare gases by distilling liquid air. They exhibited tubes filled with argon, neon, krypton, and xenon to Queen Victoria, but to the dismay of the ministers of her realm, isolating these gases was still too costly to take them to the next stage in which the process could be industrialized.

Then Georges Claude stepped in. Initially, he was looking for an easy way to produce oxygen for hospitals. His experiments left large quantities of rare gases—particularly neon and argon—as byproducts. Add a touch of serendipity and an almost bemused Claude noticed that neon could produce an intense

reddish orange and argon a lilac blue. He also discovered that by coating the empty tube with fluorescent powder, he could vary the shades of these colors.

In December 1910, Claude created quite a commotion when he demonstrated his discoveries at the Paris Motor Show held at the Grand Palais. He had developed an electrode that did not corrode, thus clearing the last obstacle to the invasion of fluorescent light. The Lampes Claude company was then established with his associate Jacques Fonsèque and, shortly after the barber's shop sign on the Boulevard Montmartre, one of the world's very first neon signs shone in white letters in the Parisian sky: it was an advertisement on the Champs Elysées for an aperitif wine. Passers-by could make out the three syllables of the Italian brand of vermouth: Cinzano. An irony of history is that Pierantonio Cinzano, the namesake Italian astronomer, is today a leading expert in and world enemy of light pollution from artificial night lighting.

In recent years, a group of French activists, who call themselves the Neon Clan, have been combating light pollution in French cities by turning off shop-window signs, the switches for which are often accessible from the street. To summarize their manifesto,[4] they maintain that "shop signs which remain illuminated all night long are advertisement aggression. Even leaving the harassment to one side, is there a business owner who sincerely believes that keeping the neon lights switched on in almost deserted streets is an effective way of boosting sales? Furthermore, the lights use up an important amount of energy. While it's being wasted, people are sleeping rough in shop doorways; not to mention the environmental impact on resources and global warming. Neon lights are preventing us from seeing the stars."

Lights at night are not just about money. In a report on the impact of light pollution on biodiversity, Jean-Philippe Siblet, director of the Natural Heritage department at the French Natural History Museum, explains that the circadian cycle regulates the biological clock of living beings. Some specialists consider that nocturnal light can lead to depression. A 2010 study produced by the University of Ohio[5] has shown that frequent exposure to dim light at nighttime can produce changes in the brain over time and lead to depressive symptoms.

Also revealing is the way in which the Neon Clan make an appeal for us to look at the stars. There is a constant in human thought to prefer the "authentic" to the "artificial," so the sunset and the stars would be more beneficial to contemplate than the halos wreathed by the electricity fairy. Nonetheless, whether natural or electric light, we are often concerned with the paradigm of sight. However beautiful the Milky Way may be, our wonder at the stars sparkling, or our worship of the sun, is the product of thousands of years of evolutionary training, perhaps the ultimate conditioning: we are programmed to love all that glitters. We are more or less afraid of the night or darkness, and we cling to our visual sense, our passion for the transparent. We are addicted to the visible, to outlines, to exposure, to objective proportions, symmetrical and palpable. Fearful of concealed monsters, we trust the wisdom of images and appearances—and Power has always known how to use them to keep the people in place. What is television if not a flickering hypnotic, mimetic neon device intended to reduce social and family pressure and diminish the threat of otherness?

To produce neon light, we need to make a vacuum in a tube, then fill it with rare gas that we feed some electrons. To produce postmodern consciousness, shall we empty the mind

and bombard it with appearances? Whereas neon always produces the same signifier, faithful to its advertising ideology, our contemporary psyche seems on the contrary hardly able to tether itself faithfully to an axis, a filter value, or a unique, foundational maxim. This is sometimes called *permeability* in the social sciences, whereby the environment is continually "in-forming" our perceptions, judgments, and actions. People's values are often not solid to the point of resisting the influence of the situation. Psychic integrity and a strong, unchangeable personality seem to be myths often exploded by experience. Each day, we are never quite the same and never quite other. For many people, awareness is not identity and even less integrity. In his *Phenomenology of Spirit*, G W. F. Hegel put it differently: "No man is a hero to his valet; not, however, because the man is not a hero, but because the valet is a valet, whose dealings are with the man, not as a hero, but as one who eats, drinks, and wears clothes, in general, with his individual wants and fancies."[6] Many wear veils of mastery in public that they drop in the ambiguous penumbra of the private.

One of the key factors in the current passion for transparency is indeed the unmasking of masters. Books on the alleged pedophilia of Gandhi become bestsellers, and the sex life of Churchill comes under the spotlight. Popular cynicism ferociously doubts the probity of the ruling leaders. But the ideal of social transparency is interesting so long as it does not aim blindly to drag people down into the mud of general distrust. The twentieth century has devalued the just, sound master and favored instead the guru and the star, whose appeal is more stupefying, albeit ephemeral. The obsession with a fascinating identity, social visibility, and rapid return on investment is accompanied by a stultified conception of being, fixated on the fluorescent mode of the brand image. Our absolutes are often measured by

the yardstick of the money they make. One of the negative consequences of the overexposure of all is that it might favor mediocrity rather than courage.

Sartre was not yet overexposed when, during the Second World War, he wrote *Being and Nothingness*. He had found his absolute; it was not knowledge or the speed of light, but existential consciousness, intangible consciousness, which results from the contemplation of vacuity and which precedes essence. He writes, "Consciousness has nothing substantial, it is pure 'appearance' in the sense that it exists only to the degree to which it appears. But it is precisely because consciousness is pure appearance, because it is total emptiness (since the entire world is outside it)—it is because of this identity of appearance and existence within it that it can be considered as the absolute."[7] A strange absolute, which is and is not at the same time.

The absolute is a big deal for philosophy. When I read Kant's *Critique of Pure Reason*, I was agreeably surprised by the arbitrariness of some of his pages, as he is generally considered to be the most neutral of rationalists. The same impression applies to Spinoza, the smiling sage whose house and statue now contemplate the neon signs of The Hague's red-light district. He affected to write his *Ethics* solely according to mathematical principles, but, despite his rigor, his reasoning often hops and he deems some truths as so plain as not to need any time to prove them. His pages are littered with facetious examples of *Quod erat demonstrandum*, Latin for "which was to be demonstrated," as if he was implying, they are things *which should be demonstrated, but I prefer to assert them.* As for Plato, he didn't even bother with an analytical style but assumed Socrates's aporetic mask and had him dialogue with simpletons so that he was always right. If you read the great philosophers attentively,

you will find that they don't hesitate to thump out some untimely truths. The history of thought is not only peopled with dry, pernickety clerics, machines of gray austerity, but also with sensual, active, assertive visionaries who tend to the sometimes monstrous unified vision, like prophetic titans, punching out their systems like boxers, all the while parrying blows aimed at their heads or beneath the belt. Nietzsche was right about this, and he was not alone in thinking in hammer strokes.

Those who ask too many questions are not made for philosophy, no more than those who claim a human truth ought to be as solid as a mathematical calculation. Never mind the clerks who now want us to believe that thought can be impersonal, the supreme beauty of philosophy is to be a hymn to the faith of tomorrow, a composition that creates a new perception of reality. Philosophy is actively faithful to this twofold idea: that society is always ideological and that all ideology is replaceable.

Wise thinkers know that it is difficult to prove truth because truth is also a feeling. What interests them is instead how to assert the cogency of their arguments over time, to structure ingeniously the complete network of their conceptual world and understanding of it. Truth is a type of music that emerges from the composition and orchestration of a system of propositions, rather than an isolated axiom extracted from this system like an acutely bright neon light. The fancy philosophical slogans like "existence precedes essence," "I think therefore I am," "being is and not-being is not," or "know thyself" are only fluorescent façades, fragments of philosophical refrains that operate like advertising jingles. They resonate in isolation, as if we played the *da da da dum* theme of Beethoven's Fifth but forgot to play the rest of the symphony. Philosophy, taken more seriously, can rupture the power of today by giving an idea of the power of tomorrow.

It is now time to answer the question: What was the first word spelled out by a human with tubes of light? Several sources attribute paternity of the first fluorescent signifier to Johann-Sebastian Bach's friend, the philosopher and experimenter Johann-Heinrich Winkler. We know that his experiment took place in Leipzig in 1744. In Winkler's book, *The properties of electric matter and electric fire, explained from various new experiments and described thanks to several new electrifying machines,*[8] published in Germany in 1745, we find the following sentence: "Some high personages, to whom I had the honor of showing these electric experiments, were particularly delighted when they saw the first letters of the name of *Augustus Rex* bursting forth and shining with extreme clarity in the open air, and burn likewise in a room where everything was dark; and that they were able to observe the tumultuous flow of electric light passing through and filling the letters of glass with one stroke." Winkler was paying homage to his king, Augustus III, prince elector of Saxony from 1733 to 1763, king of Poland and grand duke of Lithuania.

Augustus Rex. Absolute power consecrated by the ancestor of neon. Augustus meant *the increaser* in Latin, from *augeo,* "to grow." The magical formula of power: pick a value (such as "divine royalty"), grow it into a protective and feared fetish by multiplying it under various forms, until it is incorporated by the many as a cognitive armure, one that both protects and constrains. Power seems to have a body of iron, but it is molded in glass and light. It can easily be broken into pieces.

Homo economicus, that is to say the person who accepts reality or systematically responds to the changing variables of his environment, indeed appears to be malleable.
—Michel Foucault[1]

SUBLIMISM

Christmas is coming, and for the past few days the trees on the luxurious Champs Elysées Avenue have been covered with luminous hoop-like halos, bristling with high-output, low-energy LEDs. It's a far cry from the Cinzano neon sign that taunted the Arc de Triomphe one century ago. LEDs are colder, and close up their spikiness deprives them of some magic. They were invented in 1962 by Nick Holonyak (first in red). They were gradually used for traffic lights to manage human flows and then for domestic electrical appliances. Since 2003, following the fashion-setters Audi and Aston Martin, they have been found festooning the head and rear lights of cars. As of December 30, 2012, one hundred years after the first neon signs, classic filament light bulbs were outlawed in Europe, leaving the way clear for the triumphant reign of the LED, also reckoned to produce less carbon dioxide pollution. Despite all this, in many historical capitals of the world, our centenarian neon is still hanging on.

In 1923, Earle C. Anthony, a Los Angeles businessman, took the neon technology from Paris to the United States in deep

reddish letters edged with blue (the opera colors). He put up a huge sign for the carmaker Packard on a Hollywood boulevard, which was so stupefying in its novelty that for the first few months it caused accidents and traffic jams and elicited the helpless disapproval of the local police.

This was the beginning of Georges Claude's fortune, as he started to sell licenses across the United States; his monopoly was built on a patent for a long-lasting electrode. In New York, Chicago, San Francisco, Detroit, Pittsburgh, and Boston, the franchisees agreed to pay US$100,000 plus royalties for the right to produce French neon lights. Claude was thus one of the precursors of the commercial distribution model that would be developed in the 1950s by General Motors and McDonald's. Claude's monopoly lasted until 1932. In 1927, of the 750 neon signs adorning Manhattan, 611 had been manufactured by Claude Neon Lights, Inc. The big-business hegemons blazed their brands across the New York City skyline: Remington typewriters, *Scientific American* magazine, Lucky Strike cigarettes, and more.

In 1929, in the midst of the Wall Street crash, Claude Neon Lights, Inc. increased its turnover by 40 percent to reach some US$10 million. Three years later, once the patent was less protected, its competitors launched an assault on the luminous capitalization of the night with rival artisanal creativity. Each neon is unique and more or less sophisticated, the fruit of delicate handwork. In the sky at that time, you might have seen the luminescent Goodyear hot air balloons, which only went out with the Second World War. Neon contagion was spreading quickly and internationally. During the same period in Paris, the Gare du Nord railway terminus emblazoned its façade with a huge neon locomotive, accompanied by a sign saying, "Paris to Liege, 367 km in four hours non-stop."

In the 1930s, the fascists were not reluctant to use this crowd-pleasing technique. A little before the war, on the hills above the papal city, you could read in Mussolinian letters of light *È riapparso l'impero sui colli fatali di Roma*, "The Empire has reappeared over the fatal hills of Rome." Further north, Nazi propaganda minister Joseph Goebbels understood the utility of using neon to write *Ein Volk, ein Reich, ein Führer* in big, white, capital letters superposed with a swastika on the Berlin skyline.

By the end of the first half of the century, Times Square in New York acquired its legendary cacophony of colors as the city became the second capital of neon. Sunday strollers would admire the new forms created by the glass blowers and twisters; on an official visit, after the war, even General De Gaulle was taken to have a look. The former leader of the Free French Forces did perhaps know that he was admiring a French invention while he looked at these neon creations. Yet his advisors might have kept quiet about it, given that Georges Claude was in prison at the time, serving a life sentence for his overzealous wartime admiration for Marshal Pétain, the collaborationist Second World War French leader. Claude was released in 1950 and, ever untiring, embarked on a project to extract energy from seawater; he was convinced that the oceans would one day provide our main source of thermal energy, as Jules Verne had imagined in *Twenty Thousand Leagues under the Sea*. Visionary? Time will tell.

During the 1950s, neon became the symbol of the American dream, as if hypermodernity had decided to slum it in the land of the greenback, aspiring more to capitalist liberalism than to egalitarianism. The emigration from Paris of the Statue of Liberty, sculpted by Frédéric Auguste Bartholdi in 1886, was undoubtedly a precursory indication of the way things were

heading. In the effervescent post–World War II United States, a creeping growth of fluorescent tubes advertised cocktail bars, cinemas, motels, and even florists and would end up scratching from the dust a greedy town in the middle of the desert. Describing his arrival in Las Vegas for the February 1964 issue of *Esquire* magazine, Tom Wolfe wrote: "Las Vegas is the only town in the world whose skyline is made up neither of buildings, like New York, nor of trees, like Wilbraham, Massachusetts, but [neon] signs. One can look at Las Vegas from a mile away on Route 91 and see no buildings, no trees, only signs. But such signs! They tower. They revolve, they oscillate, they soar in shapes before which the existing vocabulary of art history is helpless."[2] Later, he added, "It was the only architecturally unified city I ever saw in my life other than Versailles, and the unity was created by the signs."[3] Meanwhile, back east in New York City, folk singers Paul Simon and Art Garfunkel were recording "The Sound of Silence": "I turned my collar to the cold and damp / When my eyes were stabbed by the flash of a neon light / That split the night / And touched the sound of silence"—a sublime lament in the immemorial war between sound and light, which seemed to have turned definitely in the latter's favor.

From then on, an "architecturally unified" city would be a city with a strong neontic identity. In his 1995 book *The Generic City*, architect and urban planner Rem Koolhaas wrote, "The stronger identity, the more it imprisons, the more it resists expansion, interpretation, renewal, contradiction. Identity becomes like a lighthouse—fixed, overdetermined: it can change its position or the pattern it emits only at the cost of destabilizing navigation. Paris can only become more Parisian—it is already on its way to becoming hyper-Paris, a polished caricature."[4]

The hypercity tends to lose vitality and transform into a "generic city," defined by Koolhaas as "what is left after large sections of urban life crossed over to cyberspace. It is a place of weak and distended sensations, few and far between emotions, discreet and mysterious like a large space lit by a bed lamp. ... This pervasive lack of urgency and insistence acts like a potent drug; it induces a *hallucination of the normal*."[5] The poles have fused; there is no longer any difference between desolation and frenzy. Neon signifies both the old and the new, stupefaction and normality.

Yet mystery has perhaps not totally deserted our cities, but rather has been put under glass, *climate-controlled* by theatrical design. When a child visits Disneyland, her imagination essentially creates a significant part of the magic of the place, yet she is not paid for that. Although historic streets have been crystalized into urban showcase service stations, we still do have the choice to be either malleable, voiceless, sleepwalking spectators or instead the assertive inventors/discoverers of new spaces for tomorrow's world.

At the end of the 1950s with the invention of psychogeography, the situationists had already intuited urban exploration as an adventure of good fortune and desire, an ambulation of the imagination drifting on the waves of interactive relation and "objective chance"; the surrealist lineage was clear. The concept of *situation*, partly inherited from Sartre, points to a determination to question a falsely sentimental human nature, stuck in the security of commercialism and bound by a visual paradigm. Guy Debord writes: "It's easy to see how deeply the principle of the spectacle is rooted in the alienation of the Old World, i.e. non-intervention." Conversely, "the situation is made to be lived by its makers. The role of the 'audience,' if not completely

passive or non-speaking, must always be diminished, whereas the share of those called actors—or 'livers' in a new meaning of the term—must always increase."[6] Of course, vanilla versions of this form of existentialism have been taken on board by reality TV or the events and advertising industries.

Democratization of the will to create our social reality is a principle that confronts the so-called realist economy; it excites our passions and defines the tonality of our new civilizational mood. The twenty-first-century citizen dreams of taking her own destiny in hand. As a faculty attributed to humankind, creativity is more recent than it might seem. It was not until 1623 that the Polish poet Maciej Kazimierz Sarbiewski clearly formulated the idea of human—rather than exclusively divine—creativity. It was still a faculty reserved for the poet who, "in the manner of God," is deemed capable of creating something new. Progressively, the makers of other arts were culturally considered "creative," followed by craftsmen and engineers. At the end of the nineteenth century, Nietzsche's announcement that "God is dead" undoubtedly expedited the fall of the idea of creation into the public domain. The key to paradise had finally dropped to earth.

Since the origins of hierarchy, tools, and language, humans have sensed confusedly that reality is partly the fruit of their aspirations, perseverance, imagination, and work. However, until religious submissiveness was radically questioned during the Enlightenment, the faculty of creation was commonly considered to be a divine privilege—or at least one reserved for the dominant elite. Mister Nobody had to be content with "free will" to get along with "providence," put order into what fate had dealt him, or make up as best he might for God's failures. Only saints, wise men, poets, bishops, kings, princes, and aristocrats

had the signal honor of being the cherished children of the Creator, the august guardians of Being.

Although humanity has long been determined by the paradigm of *domination*, humans now seem increasingly interested in the cause of *creation*. "Co-creative" awareness is the active aspiration to be coauthor of reality and truth, with the risk, however, of making the human the belly button of the world. In the twenty-first century, we are likely to witness, not without conservative resistance and despite a seemingly discouraging social landscape, a global tendency that weakens the individual as competitor and ushers in social relationships that are more globally harmonious. In his 1486 *Oration on the Dignity of Man*, Giovanni Pico della Mirandola gave permission to humans, by the will and voice of God, to thrive towards autonomy: "We have made you neither of heaven nor of earth, neither mortal nor immortal, so that you may, as the free and extraordinary shaper of yourself, fashion yourself in the form you will prefer. It will be in your power to degenerate into the lower forms of life, which are brutish; you shall have the power, according to your soul's judgment, to be reborn into the higher orders, which are divine."[7] The Renaissance man identified his freedom with that of the sculptor or painter, both visual artists concerned with tangible objects and perspective. They were aware that the archepower of being an initiator rather than a disciplined part of a traditional group contained its danger: the risk of regression and dissolution into caprice or self-indulgent idleness.

Many individuals and groups are still attracted today by the totem of objective domination, fascinated by the prisms of hierarchy and tutelage, stuck in a fatalist world view, or aware that most people still need a collective and institutionalized structure of discipline (the family, the firm, the state, the association ...)

to remain decent or spirited. It is not easy to shake off habits acquired throughout thousands of years. Simultaneously, the ambiguous idea of "empowerment" holds great sway—for instance, in designating the emancipation of minorities. How might we imagine that power could be detached from a desire for domination or sovereignty? Would it not be preferable to slough off like an old skin the idea of power as enhancement, even if it is a "counterpower" serving a minority? Should creation not be something radically other than a form of agonism or self-affirmation? Just because someone's instrument is more heard does not mean he plays more in tune.

Despite the creative spirit that spread throughout the twentieth century, one could argue that globalization has not gone far enough in broadening our perception of the world. Planet Earth does not suffice as our spiritual horizon. Not only are there several possible worlds, but living in them harmoniously supposes reconstituting a supersonic, exohuman, cosmological consciousness—a shared cosmology. We might consider that the sentence "The world is/must be my creation" should only be uttered by a demiurge, god, or goddess. However, it lies now truly at the root of human aspiration without necessarily presupposing megalomania or delusion. "The world is/must be my creation" takes on a paradoxical and dynamic meaning if many people utter it at the same time. Indeed, creations of reality as they become manifest are not about individualism, each and every individual blindly defending his or her own liberation. *Creal* awareness, as we will see, is concerned with going beyond the illusion of the all-powerful ego and refers to a co-creating cosmos and social well-belonging. In other words, the world is our echo.

Some people maintain that politics begins with indignation, whether the scandal or moral ugliness or the cruelty of injustice imposed by others. We struggle against the torpor of our

powerlessness and unformulated urges to take action. We want to be a part of the widespread condemnation of "harsh social reality," but we still endure and consume the "capitalist," "humiliating," "disrespectful," "ugly," "unjust," or "normative" realities. From everywhere, we hear the clamors against "a sense of reality" that would have us adapt, at whatever cost, to the established order—and we might remain more or less reluctant to become standard-bearers. The aspiration to live intensely and freely, to exist in spiritually rich and physically glorious modes of being emerged here and there over the last centuries in various historical forms and locations. But are we certain that the history of social relations, of urban consciousness, of political or cosmopolitical action has led us to an era of sustainable co-creation? Are we soon to reach the shores of paradise on earth, or are we singing the swansong of freedom in a collective delirium of omnipotence, which will end in a digital mass drowning?

"We would at any price re-enter into life,"[8] proclaimed the Italian futurist painters, who organized their exhibition in 1912 at the Bernheim Gallery in Paris, inscribing their names in neon on the façade: Boccioni, Carrà, Russolo, Severini. They were seeking to dissociate the creative process from its elitist, aesthetic aura to promote instead a "polyphony of the senses"; not only would there no longer be a border between technology and art, but their purpose would be not so much the beautiful as rather a more vivid daily existence—whence the futurist slogan, "Let's kill the moonlight!" and their electrical acts of defiance to the stars. The use of the emerging technique of neon struck the numerous visitors. The futurists were Georges Claude's first artsy clients; since then, an entire codex of aphorisms, words, and names has been written in neon letters by the ongoing history of contemporary art.

Leon Trotsky saw futurism, initiated by Marinetti in 1909, as the self-contradictory ideology of the Bohemian bourgeois. The communists considered it a form of nihilism leading to fascism. Defending the artificial against the authentic or the authentic against the artificial can reflect two sides of the same coin, like the one spinning in Plato's Allegory of the Cave. We should not completely abandon light and the realm of seeing and unwaveringly follow the invisible and unheard. We will rather happily defend a rebalancing of the senses by recognizing that we might have forgotten the creative art of listening. To listen is to say yes to the world as much as being attentive to it and to be ready to respond actively. To listen can also be self-reflective: it's about harmonizing and conducting the inner voices as much as the outer ones. Finding the sound of silence.

The sublime is not only what glints and clinks. In 1870, a year before the Paris Commune, Denis Poulot, a small employer in the mechanical sector, published a pamphlet alerting the authorities to what he considered to be an alarming number of Parisian workers referring to each other as *sublimes*, meaning that they were fully aware of being the true actors of industrial production. A song that was then popular among the rebels proclaimed: "Son of God, earth's creator / Let's all carry on our trade / Joyful work is holy prayer / What pleases God is the sublime worker" (Fils de Dieu, créateur de la terre / Accomplissons chacun notre métier / Le gai travail est la sainte prière / Ce qui plaît à Dieu; c'est le sublime ouvrier).

These sublimes were competent and loved their work. Through their spirit of independence, they developed original forms of resistance to their bosses, such as mobility (constantly moving from place to place and company to company), temporary absenteeism (many would not go in to work on a Monday), and an attitude of professional authority over a boss who knew their

craft less well than they did. It was only after the arrival of the trade and labor unions, legalized in 1884, that the sublimist movement disappeared to be replaced by less well-qualified but more disciplined standardized workers, who were promised little houses in the Parisian suburbs.

In Kant's *Observations on the Feeling of the Beautiful and Sublime*, published in 1764, we are led to understand that the beautiful is inferior to the sublime because it is more conservative. The feeling of the sublime "is sometimes accompanied with a certain dread, or melancholy; in some cases merely with quiet wonder; and in still others with a beauty completely pervading a sublime plan. ... The sublime must always be great, the beautiful can also be small."[9] "What should I do?" Kant wondered. One could pastiche his moral imperative by recommending: "Act to be faithful to your inner feeling of the sublime."

In 1871, the Paris Commune—what Marx called the first autonomous proletarian insurrection, believing the proletariat held political power—broke out in the Parisian suburbs. Despite its bloody repression, it had been fertile in ideas, such as anarchism. But from that date onwards, the capitalists understood little by little that the workers should be put to sleep with a few social benefits, mass entertainment—as religion was no longer a strong enough opium—and tasks parceled into little bits to ensure that nobody was quite indispensable. Keeping unemployment at a sufficiently worrying level, plus promoting the worship of stuff and spectacle, should theoretically keep sublime attitudes at bay among the workers. Eight years after the Paris Commune, the incandescent light bulb was invented and was to play an important role in social peace, as it helped keep people at home or gazing into glowing shop windows. By domesticating light, the twentieth century would seek to waylay the sublime and objectify the intimate.

Excessive brightness drove the poet into darkness.
—Martin Heidegger[1]

THE INCALCULABLE

The manufacturing technique to produce real neon signs has changed little since 1912 and is still artisanal. How is it done? Before permanently sealing the glass tube, the air is sucked out almost completely and replaced with a small amount of rare gas. Electrodes at either end of the tube are connected to an electricity supply. The inside of the glass is covered with a mixture of fluorescent pigments, particularly phosphorous. The hue of the glass also can be varied, depending on whether it's Pyrex or crystal. As physics tells us, a small amount of gas contains millions of molecules, which in their natural state are not negatively or positively charged. To produce light, their chemical bonds must be broken to divide them into negative electrons and positive ions; this provokes a frenetic dance of attraction and repulsion: a chaotic choreography know as *ionization*.

I had the opportunity to watch one of the now rare glass-blowing craftsmen, the French neon maker Nasser Bouleknater. He starts by drawing his design on heat-resistant paper. He then chooses pieces from his stock of tubes 3.2 meters long and 6–25 millimeters thick, which he has in several different colors. He

then heats a tube with his blowtorch to between six hundred and eight hundred degrees. The glass becomes "docile" for a few seconds, soft enough to be shaped into curves. The skill is in being dexterous enough to place the tube above the drawing and follow it quickly; any handling error at this stage is difficult to correct. As the craftsman twists the glass, he blows into it to stop crinkles forming. A good neon maker never uses gloves so that he can feel more closely the variations in the consistency of the glass. To produce a sign can take from a few hours to several days, depending on how complex the design is; this was already the case in the 1920s, when neon production became an important business for the workshops of Parisian glassblowers.

Philosophy is a craft too. Its practice shows you that the disparate, the apparently irreconcilable phenomena, can sometimes be manifestations of the same epochal or universal atmosphere. At the point we've reached at the beginning of the twenty-first century, we may feel that being and neonness have become analogous. Our consciousness likes to mime brand imagery. The brilliance of communication media, shop windows, and digital screens simulate starlight, and we are stupefied. Many human beings are like a vibration imprisoned in a glass tube, crystallized desire, commanded to produce an identical, bankable signifier while reflecting with panoptical transparency the world of objects and beings around them.

When psychoanalyst Erich Fromm published his best seller *To Have or To Be* in 1976, the extreme distinction between the modes of possession and intimate sensitivity sounded with some force in the ears of a readership attuned to New Age mysticism. But nowadays it seems that *being* no longer refers to lively immanence: to be is to have (social recognition or things), to attract attention, to enjoy a quantified social standing and

digitized aura. Exhibitionism and voyeurism are the twin teats of the visible empire. In Einstein's theory of relativity, the only absolute is the speed of light; perhaps Einstein did formulate the spirit of the times in physical terms. The hyperclarification of the obscure has become a flourishing market. Penumbras are uncomfortable in a world in which everybody seems to need to be visible in order to survive.

For some, being in the spotlight, closer to the absolute of light, seems to reflect a form of secret wisdom and legitimate power: if such a person were famous and successful, many think she must know something that others ignore, possess some magic power—and therefore she deserves it. The idea that stars and famous people have something important to say just because they are famous would have been considered ridiculous a few centuries ago. Clearly, the capitalist imperative of ubiquitous profitability plays a role in our fascination for people who attract attention and money. Essayist William Deresiewicz even talks about us as a "Generation Sell."[2] Quite pessimistically, he claims that "today's ideal social form is not the commune or the movement or even the individual creator as such; it's the small business. ... Today's polite, pleasant personality is, above all, a commercial personality. It is the salesman's smile and hearty handshake, because the customer is always right and you should always keep the customer happy. ... The self today is an entrepreneurial self, a self that's packaged to be sold."

In the 1930s, several Parisian cafés adorned their ceilings with curved neon lights, as if creating their own overhead cosmos. It is hard to imagine a widespread use of this type of decoration today: First, it would distract attention from the being seated opposite us, who might be a potential customer. Second, we have become the neon signs ourselves. Refusal to be a neon, an

easily identifiable sign in mercantilist networks, may feel like banishment to the shadowy purgatory of unsold stock.

One evening, while I was walking over the Pont Neuf on my way to the Café des Fous, where I read out loud, one chapter at a time, the first version of this book to regular guests, I noticed a barge gliding along the Seine, lighting up the night. A green neon light entwined itself around the boat, the name of which was lit up in the same color, *Le Sans-souci* (The care-free), an apparition that would have amused Martin Heidegger, author of *Being and Time* (1927). Existing for Heidegger was never without care. And who could honestly claim to live without worry? The French word *souci* ultimately derives from *solsequium*, the Latin for sunflower, evoking the excitement and anxiety of chasing the sunlight. Even those who claim to have reached a state of minimal disturbance, a relative nirvana of psychological grace, may succumb to worries—for example, to the concern of becoming *pure desire* without, in fact, desiring anything in particular. Some may desire themselves for themselves and become preoccupied with becoming masterpieces of being, hyperneons.

Self-development is a flourishing sector of the economy, driven by the consumer's imperative to become a luminous, positive being, shiny and attractive. Books on self-improvement, often variations on the theme of autosuggestion pioneered in the early twentieth century by Émile Coué, account for a significant share of book sales in shopping malls. Searching for online self-help books using the keyword *light*, you will come across a plethora of titles, such as *Living in the Light*, *The Healing Light*, *Light from the Darkness*, *Light Is the New Black*, or *Manual of the Warrior of Light*. Manufacturing your own self often takes light, clarity or transparence as its ultimate template.

In the Roaring Twenties, the number of American expatriates living in the City of Light increased from six thousand to more than thirty-five thousand. James Joyce's experimental novel *Ulysses* was published with a print run of one thousand copies by the Shakespeare and Company bookshop at 12 Rue de l'Odéon. Marcel Proust was dying as building work began on the Paris Mosque, and across town, around the corner from the recently neon-decorated Garnier Opera house, the young Ernest Hemingway was talking with Ezra Pound at Harry's New York Bar, which was to become the headquarters for the postwar Lost Generation, avid for real, bohemian life. In the final lines of *A Moveable Feast*, Hemingway wrote that "Paris was always worth it and you received return for whatever you brought to it. But this is how Paris was in the early days when we were very poor and very happy."[3] Hemingway felt that Paris was about to change and its idea to migrate. Meanwhile, Émile Coué was becoming famous in the United States, where he had landed in 1923, the very same year as neon. Coué proposed a neontic method of autosuggestion: to repeat and repeat the same personal slogan until you shine more brightly and feel more adjusted: "Every day, in every way, I'm getting better and better." The problem of such an escalating form of self-development is that it implicitly suggests that every day is imperfect compared to the hopes for the next day. This can generate constant dissatisfaction.

In France, like elsewhere, there is no integrity card, but an identity card, which in the twentieth century has had a parallel destiny to neon. Invented also in 1912, it was then called *carnet anthropométrique* (anthropometric permit). Initially compulsory only for the nomad fringes of the populations—that is, gypsies and Bohemians—the identity card spread to the rest of

the population in the 1920s, at the same time as the fluorescent tubes began their conquest of the night.

In the same decade, an eternal flame was installed in the Arc de Triomphe, next to the Tomb of the Unknown Soldier. A stone's throw away, at the Theatre des Champs Elysées, Darius Milhaud presented his ballet, *The Creation of the World*, with a libretto by Blaise Cendrars and choreography by the Swedish dancer Jean Börlin, inspired by Harlem jazz. During this time, physicist Louis de Broglie was calmly establishing the wave-like nature of matter, one of the major (re)discoveries of the century. In 1925, the anthropologist Marcel Mauss published his class work *The Gift*, which came out in the bookshops at about the same time that the Michelin guides started awarding stars to restaurants and luxury hotels.[4] Meanwhile, in Germany, as the Second World War was brewing, Heidegger was putting the finishing touches on a fundamental text entitled "The Age of the World Picture." In this lecture, he tells us that we should have "the courage to question rigorously the truth of our own assumptions and the scope of our own aims." Such a questioning should aim to "know the incalculable" and be a "creative questioning."[5]

Heidegger is known as the champion of *Being*. It is not an innocent choice to use the word *Being* rather than *Becoming*. In German, "to be" is *sein*, in which we hear the article *ein* or "one," which we encounter, for example, in the slogan *Ein Volk, ein Reich, ein Führer*. Heidegger's conception of being, one still colored by monotheism and a passion for unity and undivided power, is certainly not incompatible with a passing fascination for a "providential" regime that would be based, as was Nazism, on a so-called natural superiority and racial unifying principle. It is convenient to believe Nazism is completely a thing of the past—yet we need to answer the question of why the idea of

physical superiority, connected to the pervasive power of the visual paradigm and measurable tangibility—for instance, in terms of symmetry—is still a strong value of our epoch. With our passion for dollish bodies with digital proportions, do we not echo the Nazis? Were they not the violent markers of the aesthetic era, which finally consecrated the identity of being and appearing? We know that Goebbels liked neon signs and did not shy away from using them in public spaces for propaganda purposes. His swastika was a night-light before it became a nightmare.

The cult of a superior entity, one who is more powerful than humans—the Light, the Sun, Being, Nature—often entails the devaluation of individual independence and can usher in a form of totalitarianism built on the dialectical model of a nonhuman chaotic force and a political taming order that can illuminate the path forward for the good of the people. Robespierre's cult of the *Supreme Being of Reason*, proposed just before the French Revolution was stopped in 1794, is sometimes presented as the first modern failed attempt at a "democratic" technique of fascist domination. But what about our contemporary neonness? What does it say about the relation between our ubiquitous paradigm of light or transparency and our technological regime of over-rationalization and commercialized identities?

For Heidegger, the essence of modern times is indeed technique, itself an expression of anthropocentrism, a tendency to consider everything as "objects of experiment" for a "subject" who aims at a certain level of dominion over nature. This can be seen as an extension of the outputs of physics as a science. The "ground-plan of nature"[6] we have adopted presupposes that "every event, if it enters at all into representation as a natural event, is determined, in advance, as a magnitude of spatio-temporal motion. Such determination is achieved by means of

numbers and calculation."[7] This causes a drift in which we are tempted to apply mathematical exactitude and digital discretization to everything alive and possible.

When the imperatives of exactitude and distinction spread in the body politic and divide the senses, we lapse into aesthetics—aesthetic surgery, even—the idea that phenomena can be manipulated, tucked, and adjusted according to objective canons; the ancient Greek root of the word *surgeon* designates the action to shape matter. When the supremacy of the clear, visible, and distinct object swamps our possible worlds, we become ourselves reflected in representations: "Only from the perspective of rule and law do facts become clear as what they are. ... The method by means of which a domain of objects is represented has the character of a clarification [*Klärung*] from out of the clear, of explanation [*Erklärung*]."[8] The human being "as the rational being of the Enlightenment" unfolds a subjectivity that "gains in power. In the planetary imperialism of technically organized man the subjectivism of man reaches its highest point from which it will descend to the flatness of organized uniformity."[9] In other words, neontic self-development leads to slavery.

We tend to forget the incessant renewal of creative feeling and how to listen to the source of Being. Our time is busy replacing cogitation with coagitation and action with activism or clicktivism, producing an appearance of saturated reality, a reality of objectified iterations transformed into goods that are condemned to circulate as data. Anthrobotic orders and organizations feed on addiction, habit, numbers, protocols, statistics, archives, and currencies. Neuromarketing is shaping our existence. We remain awestruck by all this implicit symmetrical beauty, stupefied by mathematical apparitions, dumbed down

by the purity of social engineering, lulled by the representation of cartels, labels, and clusters of false belonging.

Calculation as clarification predominates. Doctors and the media use statistics and probabilities to worry their clients and make them dependent, creating a hypochondriac society in which everything is measured in terms of pathology and crisis. To feel normal, some need to identify with a diagnosis and a medical condition; we will soon no longer say "I'm going to read a book," but rather "I'm going to have a bibliotherapy session." Everything tends toward forced rationalization, exploitation, and standardization. Being is incessantly forced into the straitjacket of measurable representation. Heidegger writes that "this objectification of beings is accomplished in a setting-before, a representing [*Vor-stellen*], aimed at bringing each being before it in such a way that the man who calculates can be sure."[10]

The social contagiousness of tangible transparency and measurable realism started with Cartesianism.[11] As the human *I* of the *therefore I am* became the subject of the world, the human eye became the center of reference for every thing. Apart from the thinking subject, everything else became potentially mechanical. Before Descartes, being was the *ens creatum*, that which is engendered by the Creator, God in Person, acting as the supreme cause of a spirited universe. Saint Augustine called it *Divine illumination*. To be a being then meant to belong to a determinate rank of the created order corresponding to the cause ordained by the divine light. The absolute of the *I* in the Cartesian *I think therefore I am* is the certainty that killed animism, replaced faith in God as Creator. Creatures were no longer projections of God but mere automatons. After Descartes, the paradigm of light did not stop, but a being became a measurable reflection for a measuring subject. What did *represent* come to mean? To discretize,

in such a way that thinking is no longer meditating or admiring but rationalizing. The danger of such an analytic worldview is that it eventually transforms everything into parts in a machine, even the brain. If you play Tetris every day you will see everything as a juxtaposition of bricks. The world becomes a network of walls on which at best you can proclaim your identity as a peddling neon sign, if not a window.

Heidegger suggests a return to a more archaic way, one in which the absolute is no longer an *I think* guided by what Descartes called the *natural light*, but rather "the not yet ordered chaos." In fact, our epoch seems to vacillate between these two absolutes, between individual or social subjectivity and a *chaosmos* that can be conceived as a *creal*, a creative flow of possibilities, a complex becoming rather than simply a being. This hesitation between the anthropocentric "I create" and the cosmological "it creates" is a dialectic—or rather a *crealectic*—to which we might be softly introduced in the words of the fox in de Saint-Exupéry's *The Little Prince*: "It is only with the heart that one can see rightly; what is essential is invisible to the eye." The creal way and the Cartesian way must be carefully articulated together because they have to negotiate with the same fascination for the One, unity, and unification. The heart itself can self-destroy if it becomes obsessed by one single object of love. It needs to walk with destiny, which is not an object, but a dynamic relationship between the Multiple and a biography.

In 1912, birth year of neon signs, the *Titanic* sank, anticipating other mass catastrophes of megalomania. Is there any hope of liberation behind the gigantism of hypermodernity? There might be a growing global aspiration for a radical qualitative and spiritual leap. Such a leap might take us away from celebrating quantitative grandeur or physicalist superiority and propel us towards what philosopher Jean-Luc Nancy calls the singular

plural.[12] "As the gigantic, in planning, calculating, establishing, and securing, brims over the quantitative and becomes its own special quality, then the space of optimization and the mastery of anticipation become, through this shift, incalculable. This incalculability becomes the invisible shadow cast over all things when man has become the *subjectum* and world has become object. On this shadow the postmodern world slides into a space beyond representation."[13] Being singular plural is realizing that we are not *in front of* (a screen, a person, a goal, a world, a neon ...); we are *with*. As Deleuze and Guattari put it in *A Thousand Plateaus*, esprit de corps is the alchemy of living societies. To be is *to with*: and if *with* were a verb, we might all become *withards*, wizards of well-belonging, harmonious world-shapers.

Reality—however attractive—is called into question, and this questioning is underpinned by belief in creation, a conception of creation that goes beyond the technical gesture of renewal of materiality by humans. Creation emerges from the source of being as an irrepressible vocation, an archephilia, a love of the originating thrust, an anticipatory care for the consequences of novelty. What Heidegger calls *Being* does not simply designate beings, objects, or subjects individuated in the world, but also the invisible reverse side whence they emanate, out of which they exist: a cosmic reverberation, a "re-verb," since language is the bridge between creation and the world, the articulated vibration through which reality is formed. To create is to listen to the invisible and incalculable *Creal* (what the Chinese called *Dao*, what Bergson called *Life*, what Whitehead called *Creativity*, etc.). It is to remain faithful to this co-creative realization and to make compositions out of impressions, out of understanding and feeling. If we have become neon signs, we have not yet become digital circuits or LED lights: inside the glass corset of capitalist identity, there is still the infinite vibration of gas.

On the one side, real life and, on the other, ideal life.
—Victor Hugo[1]

THE HALO

In a prose poem written in 1869, "Loss of a Halo," Charles Baudelaire wrote how his halo, shaken by the moving chaos of the city, had slipped from his head and fallen onto the tarmac mire. Giving us a hint that we make too much fuss about light, the author of the *Fleurs du Mal* (The Flowers of Evil) does nothing to try and pick it up: "I deemed it less disagreeable to lose my insignia than to break my bones."[2] The inner structure was more important than glossy representations. In *Paris, Capital of Modernity*, David Harvey's 2003 geographical and historical text, a parallel is drawn between this tale from Baudelaire and Marx's ironical remark that "the bourgeoisie has stripped of its halo every occupation hitherto honored and looked up to with reverent awe. It has converted the physician, the lawyer, the priest, the poet, the man of science, into its paid wage laborers."[3] Halo as respectability and dignity would not be capitalist-friendly because it is still attached to the authority of a mysterious wisdom that manifests opacity. Capitalism prefers the transparent and measurable halo. If it is true that we have become proletarians of the limelight, then we need a politics of the invisible.

As the international diffraction of neon developed between 1910 and 1950, halos became corseted in advertising. Contemporary art then reacted and attempted to reclaim the sacred, calming virtue of light, a millennial idea inherited from our dependency on the sun and stars. In 1967, Bruce Nauman created a spiral on which he wrote: *The true artist helps the world by revealing mystic truths*. In 2015, Eric Michel produced an intense blue neon of the word *aura*, which he explained meant in Latin "air or breeze in movement"; *spiritus* in Latin meant breeze, breath, spirit, energy, and pride. In 2002, Etienne Chambaud hung a neon message that never lights up, with an allusion to Bartleby's famous phrase: *I would prefer not to too*. If computable electricity is the ultimate fetish of the market economy, some artists are attempting to reconnect us to its inner waves and to our deeper aura.

Neontic dialectics reached a peak in 2012, one century after the first Parisian neon sign, when the oldest and most illustrious theater in Paris, founded in 1680, displayed its name, *Comédie française*, in brothel-red neon letters in the Palais Royal's court of honor. A killjoy might infer that the gangrenous spirit of prostitution has now infected respectable institutions, which are forced to generate cash by attracting the most philistine of theater-goers, like so many moths hypnotized by the light, or that the evocation of a red-light district seems in line with the historical affinity between theater actresses and the ladies of the night. Some would say that this neon is a sign of the Zeitgeist and that twentieth-century France has indeed become a *comédie française*, a parody of its grander epoch; today it might have lost its dignity.

In 1931, Walter Benjamin revived the concept of aura to describe works of arts. He defined their spiritual aura as "a unique phenomenon of distance, however close it may be."[4]

Photographic or cinematographic reproduction, for instance, partly destroys this supposedly illusory halo and replaces it with tricks of editing and a human production of simulated reality, which Benjamin considered to be an empowering and liberating displacement. Can we speak of aura when we talk about neon? A neon light is both unique, as it is handmade, and one of a more or less similar series. Some signs or fluorescent drawings seem to emanate holiness; they manifest the closest and most familiar phenomenon of distance—that is, the present itself. Neon signs remind us that the present is both within our reach and most of the time ungraspable, something expressed in the Greek idea of kairos.

Not only is neon the metonymy of contemporary identity, but it might also be a metaphor of the present such as we understand it now: electric, energy obsessed, visible, quantitative, perpetually switched on, circular, placed under a transparent bell jar. The neontic present is repetitive, incessantly flashing on and off in autosuggestive tautology, and seems to be *under observation*, as we would say of a clinic patient. It can, at first glance, be seductive as it signals that we are here, and now, the belly buttons of data, in the center of the map, at the epicenter of enjoyment or *jouissance*, yet it acts like a smooth mirror, transforming closeness into a slippery surface. The chaos within us gave birth to stars, but they do not dance as Nietzsche hoped; they are crystallized and waiting to be liberated of an unquiet paralysis of identity. Heidegger's *Dasein* became *Datasein*.

Neon even seems to twist Baudelaire's bitter, provocative conclusion on the loss of his halo. The hooligan poet declares: "Dignity bores me. Then I rejoice in the thought that some second-rate poet will pick [my halo] up and put it impudently on his head. To make someone happy, what a joy! And a happy

soul who will make me laugh!" The choice of bitter laughter and the gutter preferred over the dignity of the halo, the saintliness, sanity, or health of which is abandoned, now seems less provocative to us than it did to Baudelaire, after one century of post-Romantic cultural celebration of antiheroic losers and their glaucous errancy: not such a good deal after all. As Nietzsche prophesied, have we not become this last man who blinks in the spotlight and laughs at nearly everything, having set aside the "sad" idea of dignity and integrity?

But Baudelaire also points to a deeper integrity, a darker halo, a poetic dialogue with the Creal that does not need the validation of others to shine inward. One of the major events of the twentieth century, the transpolitical and transnational ubiquity of artificial light made us more dependent than ever on the gaze of others. And, as Heidegger suggested, the triumph of public and private lighting and overexposure in no way contradicts the rationalist program inherited from the Enlightenment. Marshall McLuhan, the Canadian theoretician of the media, explained that vision, far more than the other senses, excessively tends to the analytical, whereas hearing is more intuitive. Hypertransparency, the tyranny of digitally mediated clarity, and predictive analytics go hand in hand to render us deaf and *ab-surd*—that is, separated from the unheard.

It is easy to see how salient Plato's Allegory of the Cave has become in the age of neon. But a crealectician would believe less in the inevitable mediocrity of illusory reality and the caricatural opposition of appearance and sunlight than in the need to reconnect with the cosmos in our daily lives, to rediscover the musicality of the universe, which is generous without sentimentality, labyrinthine without walls, polyphonic, not cacophonous, rhythmical without becoming mechanical. If we had to reassess

our notion of being, it would be as a community of belonging and creation, a faithfulness to this constantly flowing, unpredictable and yet reliable flux of signifiers, the *creal* source of mental and material realizations. A shared cosmology.

I spent several decades of my life in Paris and most of the time was dissatisfied with it, as if something became seriously wrong during the eighties. Martin Luther King said he was proud to be maladjusted in an unjust world. The poet Charles Valette declaimed in 1856: "I am searching in vain for Paris, I am searching for myself." Paris used to be an ideal of refuge for the dissatisfied. "Paris works for the terrestrial community," insisted Hugo. "Paris is the condenser. ... You think she sleeps; but no ... Paris is always in a state of premeditation. She has the patience of a star slowly ripening a fruit. Clouds pass over her fixedness. One fine day and it's done. Paris decrees an event."[5] For the ardent Hugo of 1867, Paris was a metaphor for the universal idea of the adulthood of humanity. "The function of Paris is the dispersion of the idea. ... Everything, in the intelligences scattered over this earth, which catches alight, here and there, and sparkles, is the doing of Paris. It's Paris fanning the flames of the magnificent blaze of progress. ... Paris illuminates in two directions; real life in one direction and the ideal in the other."[6] Can we still learn anything from the City of Light? Perhaps if we are not talking of the realist material Paris. Today, Paris is in New York also, Paris is Beijing, Paris is Nairobi, Paris is everywhere and nowhere, encapsulated in neon letters. The City of Light is the shadow of freedom, the shame of what we have done to it, and the global echo of future revolutions.

Humans have trouble thinking about progress without using the metaphor of light. It's perhaps only now, after more than a century of exposure to the candela and the lumen, after one

hundred years of *neonitude*, that we can really understand that there is no necessary correlation between the new (*neos*) and neon. Or better, that this correlation has to be crealectically understood, more than just analytically and dialectically.

In 1971, the year in which the word *créativité* entered the French language, British pediatrician Donald Winnicott wrote that to see the world creatively is what makes us human beings: "When one reads of individuals dominated at home, or spending their lives in concentration camps or under lifelong persecution because of a cruel political régime, one first of all feels that it is only a few victims who remain creative. These of course are the ones who suffer."[7] Ordeal is inherent in creation. Society A that thrives to become fully secure, standardized, and without alterity would end up producing lots of monotony, sadness, and harmful immature behavior. Society B, which aims at its abandonment to the "invisible hand" and with only capitalist competitiveness on the horizon, produces such stress that only a "happy" few can succeed. Sometimes, like Buridan's ass, our world seems stuck between A and B, forgetting that to create the world and reality, all the letters in the alphabet are useful, even letters still to be invented.

In his book *Process and Reality* (1929), Alfred North Whitehead wrote that "creativity is the universal of universals characterizing ultimate matter of fact."[8] The Creal, this vital chaosmos, is an immanent realm of dispersive undulations that unceasingly dynamizes us, propels our enthusiasms, sometimes strengthening our hopes, sometimes weakening our false certainties. This becomingness alternates between interference, murmur, and synergy. The Creal is the stuff our lucid dreams are made of. However, it is also true that societies and persons, if they wish to survive, must go against the law of metamorphic explosion.

We must curb, compose, and prune the wealth of the cosmic eruption that unbalances worlds and pushes structures towards disintegration. For the universe to become locally harmonious, work needs to be done to strike chords that tune listening and understanding. This has to do with the heroism of style that Hannah Arendt defined in 1958 in *The Human Condition*: "The connotation of courage, which we now feel to be an indispensable quality of the hero, is in fact already present in a willingness to act and speak at all, to insert one's self into the world and begin a story of one's own."[9]

The Indo-European root *ker*, which means "to grow," morphed into the Latin *creo* or "I create." After centuries of vexations addressed to humans in the name of reality, thousands of years of vain struggles against the "hostility" of external or natural factors, eons of conflictual distinction between the person and world, isn't it a miracle that some of us still dream of a paradise on earth, a place to dwell that is the reflection of our souls, a tangible cosmology? How is it, in the midst of our anthrobotic era, that the principle of reality has not, by force, triumphed to the point of making even the sensation of idealist anticipation impossible? We should be grateful for the fact that, far from being perfect automatons embedded in a perfectly deterministic system, like the people in Aldous Huxley's *Brave New World*, the desire to be the progenitors of our own existence still preoccupies us. To be or not to be impossible.

Crealectics starts with this active confidence in the possibility of change. It starts with the intuition that the improbable, the unheard (of), the incalculable is always rich in realities, in alternatives. Infinite probability is not conceivable mathematically but it is a creal idea. The creal emotion is the rejection of blind obedience to a preestablished moral code; it's the desire for

personal integrity, well-belonging, and transpersonal compositions that might, little by little, ensure a common symphonic destiny. Neon is a noble gas enclosed in a glass sheath. The word *gas* was coined by the Flemish chemist and alchemist Jan Baptist van Helmont at the beginning of the sixteenth century. It is a neologism that voluntarily refers to chaos, as *gas* and *chaos* are pronounced in almost the same way in Dutch. Neon is crystalized chaos, contained turbulence, an imprisonment of waves whose complaint, the slave's song, generates a certain kind of aura, a musical halo.

A creal aura starts with the realization that humanity bears within itself, irreducibly, the idea of a paradise that desires to be realized and inhabitable. Is this a slave's ideal? Perhaps. But, as suggested by Hegel in his master-servant dialectic, it is preferable to be a slave who dreams of breaking his chains by singing and working than an unimaginative master who will end up as an automatic slave, deaf to a world in which all he did was to multiply the neon *Augustus Rex*.

Knowledge casts its beauty not only over things
but in the long run into things.
—Friedrich Nietzsche[1]

THE NEW GRAIL

The Rue Sauvage in Paris (Savage Street) was demolished in the 1950s. Located behind the Austerlitz train station in the thirteenth arrondissement, this street had, according to activists Guy Debord and Asger Jorn, an "antispectacular" character that was inspiring for wandering and fostering a creative desire for action. To counter the bright, blinking lights of the main boulevards and their shop signs, the situationists, inspired by the surrealists, advocated urban adventure in the fringes of the undercity and the active experiencing of "situations." Attention to the signifier *savage* in the street's name was, of course, not random. The unknown frightens our archivistic, flatly probabilistic society, which prefers to eliminate or oversimplify problems rather than meditate on their multiple unperceived aspects.

We often organize our everyday lives at a safe distance from what might appear unfamiliar or supernatural. We herd the unusual or the excessive into a fascinating show penned in entertainment. Yet sometimes there is a social virtue about savage impressions or thoughts; the monster might be that which has not yet been *de-monstrated*, civilized, accultured, or tamed like the

fox in the story. "What does that mean—'tame'?" asks the Little Prince. "It is an act too often neglected," said the fox. "It means to establish ties."[2] Strangeness can be an anticipation: the first chord, only discordant in appearance, of a fertile and new form of life.

Ironically, the terms *ambience* and *event*, chosen by the situationists for their defense of real life, have been hijacked to such an extent that event ambience creators are now employed for weddings, children's parties and in supermarkets. As for *event management*, this has become a common industry and commercial service. *Ambiant* was inoculated into the French language during the Enlightenment by Madame du Châtelet, the translator of Newton's *Opticks*. In 1704, Sir Isaac Newton used the term *ambient medium* to designate the ether, a mysterious invisible fluid that was supposed to support bodies in space. Something ethereal in the atmosphere is what Debord's friends sought to experience, a fertile social ether, a vibrating atmosphere not enclosed in glass but circulating freely, like a joyful, confident emotion. The ethereal realm is our Creal, the vibratory domain of the unheard, the source of cosmic creativity, the breeding ground of cosmopolitics.

Today, the idea of the ether, which was rejected in the nineteenth century for being unscientific, is making a comeback in cosmology, in conjectures about dark matter and dark energy. According to most physicists, the universe is only composed of a small percentage of atomic matter as we now know it. In their view, a quarter of the cosmos is made up of *dark matter*, an as yet unknown dimension, but with propulsive, antigravitational force. The remaining 70 percent is called *dark energy*, and no researcher knows exactly how to describe it for the moment. Until the realism of reductionism is introduced into this aporia of science, why not speculate that dark energy is the real Real, the Creal, the

vibratory infrastructure of matter and life forms? Not Schopenhauer's *World as Will and Representation*, but beyond the borders of neontic reason, the cosmos as Creation and Spectrogram.

At the Louvre, we can get an idea of what a creal city would look like by contemplating two pictures by Claude Lorrain representing an imaginary maritime port, bounded by temples bathing in water scattered with sailing boats. Debord considered these two pictures to be summits of beauty, only equivalent in his eyes to the map of the Paris Metro. We might find this comparison between high art and subway maps surprising, but it established a connection between the imaginary and the body: a metro map looks like a system of capillaries and ramifications that can be found in the ground, but also inside the body. Human lungs captured in X-rays look like twin trees entwined by the roots. For those who have seen the infamous *Body Worlds* exhibition based on the plastination techniques developed by anatomist Gunther von Hagens, it is obvious that the human body is like a composition of coral: on the scale of the earth, we are like watery plants that have adopted a delirious, yet effective, development strategy, coming together in a heterogeneous combination of bones, flesh, movement, language, discursive consciousness, and technosystems. There is an analogy between the rhythmical movements of ramifications and the manner in which the Creal extends, wavelike, by diffraction, or what Borges called *bifurcations in a garden of forking paths*. What if Darwin understood things upside down? Perhaps Life does not create bifurcations and branches in search of energy and survival niches. Rather, the Creal generates bifurcations and ramifications *because* of an infinite excess energy. The overflow self-tempers by subdividing.

This intuition could explain the opposition of the twentieth century Parisian avant-gardes to the functionalism and overly

rational straight lines used by Le Corbusier and his proposal to raze the Marais neighborhood and its seventeenth-century buildings. In the middle of the last century, the Swedish capital of Stockholm partly destroyed its historical city center and replaced centuries-old wooden or stone houses with financial boxes of concrete and dark glass. The result was painful for the city dwellers, who, decades later, are still mourning the loss of a significant part of their city lungs. Clarity can create asphyxia.

If there is to be a policy to *crealize* existence, it needs to delve into the question of urbanism. During the early years of neon, when this technology started to spread along the streets of Europe, some architects mounted a defense of an aesthetic of the "existential minimum." In 1919, Article 155 of the Weimar constitution recommended decent housing for all Germans—healthful habitation—which led to the concept of *Existenzmimimum*. Yet this architecture was soon to be labeled, counterintuitively, the *New Objectivity*: so-called healthy dwelling sometimes became, in practice, a reductive form of subsistence minimum. In 1952, Letterist International, the movement that engendered the situationist sensibility, announced in its *Potlatch* journal that it detested rational architecture, which would never be an art form but was produced instead according to "police directives" and entailed "automatic resignation": "Today, the model dwelling is the prison and Christian ethics are triumphant when Le Corbusier proposes getting rid of streets."[3] Austere, closed blocks, pseudocommunities monitored by CCTV and glaring lights, combined with an encouragement to separateness, anxious resignation, and noxious acoustics, form twentieth-century architecture—nearly devoid of the playful, the exalted, and the symphonic: sterilization in building form.

The art of the urban flaneur invented in the nineteenth century has also been undermined by the scenography of the modern museum-city and the desertification of most of its streets at night. Is it still possible, as Walter Benjamin once recommended before the invention of computers, to get lost in a Google-mapped capital as one would get lost in a maze and there discover, through improvisation, the admirable regions of the soul in correspondence with the outer world? Debord noted that in a quick glance you could discover the simple Cartesian ordering of the so-called labyrinthine maze in the Paris botanical gardens and laugh at the sign that announced, "Games are forbidden in the maze." *Labyrinth* is also the term used to describe the complex structure of the inner ear. *Games are forbidden in the labyrinth*: Can there be a sounder slogan to describe the deafness of a civilization?

Why is the environment in which we live so eminently political? Debord, Benjamin, and Marx repeated that people cannot see anything around them that is not questioning their own image; everything around us speaks of ourselves. Our landscape is a living text. Yet sometimes nothing around us seems to be the reflection of our soul, and we feel like strangers in a strange town. Today's urban existence often adds spiritual isolation to physical loneliness. Is there hope? In 2009, the French president made a speech littered with criticisms of the aberrations of urban functionalism, "which has done such damage to our cities by specializing and separating areas which should, on the contrary, have mixed and brought people together."[4] One year later, his state secretary's project of Law was more ambiguous and concerned with logistics: "The spatial, functional and economic articulation of these major hubs, which provide opportunity for research, knowledge and creation, will also

have a multiplier effect. Their complementary objectives, with economic and technological specialization turned towards the future, will strengthen the economy's ability to withstand passing and structural shocks."[5]

It is tempting to be cynical about this kind of official discourse. Behind the catch-all clichés of political bureaucracy, there is an attempt to hide reality, which is that more often than not financial concern makes the urban planning decisions: the costs of building and the profitability determined by the lowest bidders lay down the law of urban reality, as a consequence of the gap that still divides the dominant political class from the utopian desire to co-create reality. The fight for civic creation is still on. The Dutch artist Constant, a friend of Debord's and a founding member of the CoBrA (Copenhagen, Brussels and Amsterdam) movement, wrote an article entitled "Our own desires build the revolution":[6] "Freedom only manifests itself in creation or in struggle, which basically have the same goal: the realization of our life."[7] This is a mission with a cosmic dimension, as an anonymous situationist explained in the eighth issue of *Potlatch*, published in 1954: "We don't want to believe that people seeking the Holy Grail were dupes. ... The cowboys of the mythical Western have everything to please us: a great capacity to get lost in play, awesome travels. ... The story of the search for the Holy Grail in some ways prefigures a very modern type of behavior." The Creal is our latter-day Holy Grail, worth a renewed quest and new knights and knightresses.

What better destiny could we wish for our cities than to become the center of a new sacred and epic existence, a kind of anti–Las Vegas for cosmic-youth source diviners? In 1670, Pascal's Wager was published posthumously, promoting spiritual beatitude, just in case God did exist in the afterlife. One thing perhaps distinguishes a creal approach from the faithful Christian ethos that

enveloped the Holy Grail adventurers: despite everything, we believe in political action in the widest possible sense, meaning that we believe in a desirable transformation of reality, here and now, the wager of paradise on earth.

So, what is a creal or situationist bet? It's a playful attempt to anticipate and divine the future like one tunes an instrument and starts playing while listening at the same time. And while we're future-stalking, how confident are we, how much faith do we put in our prayers? Idealistic faith is important in the art of bewitching becomingness. Etymologically, "to divine," from the Latin *divinare*, indicates the relationship with the divine, the gods, the spiritual energies that surround and inhabit us. This is *invocation* in the strong sense of the word, a beckoning, a voicing of desire to incorporate inspiring forces. Invisible vibrations (rather than beings) fly here and there, animist emanations from bodies, plants, wood, the air, and the shadows, waves of opaque energy, accomplices seeking magnetic couplings, activated, discovered, and invented as they are heard and understood. And if the unheard seems silent, it is because a powerful enemy is at work every minute of every day: realism, the murderous twin sister of realization.

The Islandic sagas written in the thirteenth century—for example, the strange story of *Burnt Njáll*—tell us that before Christianity replaced local beliefs, prescience was widespread in pagan countries and, if not quite banal, at least considered as the prerogative of many elders, sons of age and experience. Along the pages of the sagas, which are meant to fictionally reflect Islandic society around the year 1000, some characters can foretell the future biography, physiology, and behavior of the humans they encounter. Their clairvoyance, oracular or auricular understanding of destiny, is a form of know-how, a "know-hear": acute

intuitive audition. It's easy to understand why power-thirsty representatives of the Catholic Church wanted to control, if not wipe out, the faculty of foreknowledge. To extend its secular reign as an alienating empire, Rome was more than tempted by the fabrication of an omniscient God who became a political agent of social control. Nowadays, of course, it's quite commonplace to point out that the clergy subjugated the faithful by keeping them in a state of psychological dependence. But the ideology that God is dead and that we have become independent individuals can be equally misleading.

The Islandic sagas, written by Christian monks as propaganda tools, insist that the prescience of the elders did not prevent unpropitious events or conflict. One of the sublime romances of the Middle Ages is *Merlin* by Robert de Boron. This epic poem teaches us that if knowledge of the past is diabolical, the ability to decipher destiny in the heart of the present is in fact divine. This comes from a more open-minded form of Christianity than that which too often presided over the Vatican. Merlin is the son of the Devil and of an innocent woman:

> And when he was born, he had the power and intelligence of the Devil. ... But the Enemy had made a foolish mistake, for Our Lord redeemed by His death all who truly repent, and the Enemy had worked upon the child's mother through sheer trickery while she slept, and as soon as she was aware of the deception she had begged for forgiveness. ... God had no wish to deprive the Devil of what was rightfully his, and since the Devil wanted the child to inherit his power to know all things said and done in the past, he did indeed acquire that knowledge; but, in view of the mother's penitence and true confession and repentant heart, and of her

unwillingness in the fatal deed … , Our Lord, who knows all things, did not wish to punish the child for his mother's sin, but gave him the power to know the future. And so it was that the child inherited knowledge of things past from the Enemy, and, in addition, knowledge of things to come was bequeathed to him by God.[8]

If the Grail and the Creal denote the same vital source, a sonic emotion that can engender the real by co-realization, then this excerpt from *Merlin* is essential. Divining the future is a divine practice and desire. Realism relies on the past a great deal. Effectual idealism might be the secular name of God. Systematic realism is diabolically objectivist, but crealectics would be an anticipatory art of realizing the futures of which the present is pregnant, a magic still to be fully understood by humans as they endeavor to sublimate themselves. Merlin the diviner, the divine actor, is a guardian figure, a conceptual character of a philosophy to come.

So, when do we act imprudently? The Devil knew that God forgave repentant innocents and yet he believed that he could mislead God by fooling Merlin's mother, or at least he pretended to believe so. In fact, a divine spark still inhabited the Devil: he wanted to have a child with God. In this respect, Merlin is the child born of the Devil's repressed love for God, the gratitude that, deep down, the Past feels for the Future, that Realism feels for Idealism.

We can imagine Merlin as a child playing guessing games and then growing up into the diviner, the magician of the Creal. Merlin knows that God did not write all the pages of the future before it happens. The notion of destiny is dynamic. It is not a matter of placing yourself as a subject opposite an object, but to

connect with the very heart of the future, which is the present. Zen masters, Tao masters, mystics of all religions know it: to realize that all there is, here and now, is both transcendent and immanent and triggers the magic of realization. Look at this neon. It's just neon. Once we realize how *just neon* the neon is, we start feeling it is much more. Look at this person in the subway: she is not looking at her phone, she is not looking at anything in particular, but she has this beautiful facial expression of being both absent and present, her eyes wide open. She is starting to realize, but she doesn't know yet what she is realizing because she doesn't know yet it's also up to her. In this moment she is realization, without an object.

Divining what is to come is to be attentive to the impressions through which the Creal speaks to us and then to pick out a sign as a pointer in the vital flux and thereby modulate one's action. The crealectician is a musician who seeks to participate in the composition of the music of creation harmoniously. Where our soul is enchanted, that's where we want to exist. Divining what is to come is also to *make it* divine. Our desire is not all-powerful. It is only a part of the greater, creal desire, the jouissance of what is to come, which sometimes mocks us as limited individuals. As philosopher Baruch Spinoza argued, what seems to die or to suffer is recomposed otherwise. The eon signs that our souls are, are constantly changing shape.

If we were Greek, we might say that the Creal's chief nymph is Echo. A spirit of the springs and the forests, she tried to save Narcissus with love, but he was too bound up in his own superficial reflection, his personal neon. In the end, it was the great Pan, the great wild Everything, a son of eons, who honored Echo with his desire and scattered the fruit of this union across the earth in the form of jynx, the ubiquitous birds who can turn their heads in all directions, almost to 180 degrees.

The crealectic wager is to gradually superimpose onto psychoanalytical sublimation—which is still a reactive way of dealing with one's own denials, since they are still perceived as denials—a more affirmative "echonomy" (from the Greek *ēkhố*, resonance, and *nómos*, the rule): divination through active hearing, fidelity to cosmic panphony and co-creation of the Logos, presentiment rather than resentment. To predict and decide is an intuitive and sensorial practice as much as it is rational. Crealectics are not only about the Logos of co-creation, *crea-lectics*. It is also *Creal-ectics*, from the ancient Greek *éktós*, which meant "outside, exterior." The inside reflects the outside and the outside reflects the inside.

We sometimes have impressions that we later realize were premonitions. We have dreams and think of hypotheses whose obscure clarity seems to announce the prolongation of certain events. During the very first instants of a meeting or an undertaking, we detect signs that our fear and determination to archive the present sometimes suppresses. We are used to saying that humans do not know much about the future because their understanding is limited. Let's set this defeatist commonplace to one side and insist instead on the proposition that we have some faculty of prescience that most of the time we repress. Our precognition is untrained, but this does not mean it is a chimera.

Or could it be that we are motivated by a passion for the unexpected that is more tenable than our desire for complete knowledge? Deep down we are perhaps far more lucid about our futures than we claim to be. In our own intimacy, we might prefer failures or surprising triumphs, heartaches and coincidences, rather than the mechanical confirmation of forecasts. But why would we give up, more or less consciously, our ability to foreknow our destiny? Perhaps because we want to feel emotions, good or bad. *Amor fati* was a love of fate advocated by the

ancients and revived by Nietzsche. It might feel absurd and even scandalous to accept destiny. What does *Amor fati* really mean? Perhaps this imperative: do love fate, but love it not as someone who gives in, renounces, and accepts the unacceptable, but as someone who, guessing the future, prefers to give it the opportunity to surprise him, at the risk of the unknown. Through elegance, taste for action, emotion, and play, we would willingly limit our morbid will to control the future.

In this *light*, or rather voluntary penumbra, the crealectician will not seriously believe in the Nietzschean theory that everything is only about *will to power*. What defines the human is rather a kind of will to powerlessness at the same time. Remaining in a state of imperfection or semi-blindness might be necessary to keep the creative and desiring impulse alive. Let us remember this politeness of the Universe itself: never to be quite *one* for the sake of creative multiplicity.

But what becomes of the identity-neon seen from the perspective of this hygiene of playful vulnerability? Probably a kind of republican humility, speaking in the first person, in one's own name, far removed from the desire of wild domination, totalitarianism, and collectivist hypocrisy, a singular prudence that can give the unheard (of) a chance to be more fairly distributed. The limited self is not just a damaging illusion, it's also a courtesy of the Creal. The integrity of being, the style of a signature, the fair play of self-restraint, the good taste not to overdo it, not to impose one's presence, all this contributes to countering the stupefying quackery of the all-power merchants, the fundamentalists of this world and the one beyond. As the Portuguese saying goes: "The one who wants everything loses everything." This can be read classically as a warning against hubris. But is can also be read as an

imperative: in order to obtain everything, you first need to lose the world of things.

As the flashy order of capitalism, a glittery serpent winding around the globe, daily hisses a squalling cacophony of dazzling vulgarity and absurd overexposure, many creal poets work in the dark to send forth a subtle echo, composing a vast, many-handed delicate anticipatory symphony. Now you see them, now you don't. The slogan of existentialism was as follows: Existence precedes essence. One formula of crealectics is: Futurition antecedes fruition.

Here we strike coins and people's minds.
—Motto of the Paris Mint

THE MINT AND THE MUSES

I returned to the trigger neon on the Quai du Louvre. Looking around, I became aware of the façade that sits on the Quai de Conti over the river Seine: it's the palace newly renovated that houses the Monnaie de Paris. The Paris Mint is the oldest French institution, invented in 864 by Charlemagne's grandson, Charles the Bald. For a thousand years, Paris has developed and wrapped itself around it. The Paris Mint is responsible for striking the currency used in circulation and produces millions of Euro coins every day. It also molds medals and official decorations, casts precious art objects, and is all the while responsible for combating counterfeiters and fake money.

The nobility and size of the building may seem surprising. The 117-meter-long façade consists of a rusticated foundation level; above this, five semicircular arched doorways in turn support six ionic columns, and on the entablature stand six large, allegorical statues depicting Prudence, Abundance, Justice, Peace, Trade, and Strength. The side façade is decorated with statues representing the elements: Earth, Wind, Air, and Fire. Inside the courtyard, the templelike pediment displays more

statues—Experience, Fortune, and Vigilance. The word *money* comes from the Latin *Moneta*, an epithet for Juno, queen of the gods. She was the Roman equivalent of the Egyptian goddess Isis. The temple dedicated to Juno Moneta stood on the Capitoline Hill and was where money was minted—perhaps superstitiously, as she was believed to protect the city's funds. The molds used to produce the coins were called *matrices*. Moneta was also a name for Mnemosyne, mother of the muses and the Greek goddess of memory. The official motto of the Monnaie de Paris is unambiguous: "Here we strike coins and people's minds."

Even the Little Prince has his designed medals for sale; one of them, made of gold, is called *Essential Invisible* and costs a little more than 500 Euros. Here's how the merchandise is described online: "Published in 1946, *The Little Prince* by Saint-Exupéry, is one of the world's most widely-read books. To celebrate its sixtieth anniversary in 2006, the Paris Mint produced a collection of themed jewelry and medals to capture the sweet, poetic *Little Prince in the stars*."[1] Indeed, a mind-striking way to manifest the *Petit Prince*'s truth, according to which "it is only in the heart that one can see rightly, what is essential is invisible to the eye." Moneta, mother of the muses, protectress of poetry, together with Isis, Juno, and Gaia, goddesses of nature and renewal, let us look no further for the epicenter of the City of the Light. As long as we let our psyches be stamped like metal coins, we will be like neon signs, ready to advertise ourselves without even blinking. Of course, the capitalist spirit that colonizes the space of creativity and appropriates intangible assets, hoovering up the poetry of the little princes, perverting the little or less little princesses, is not so new. Capitalism, which is not just an economic system but a mode of power, has always been ideological,

thirsty for psychological justification, an accomplice of the need for religion, the pimp of the muses. From its origins, not content with striking money, it does its utmost to strike minds too. Capitalism is a fundamentalism.

Our society as a whole can be seen as an immense mint factory of taste and distaste. We may say that we love life and poetic stars, but in the end we often do so, like the Romans, by worshiping Juno and minting in her very temple the money that is the forced language of too many of our exchanges. The situationists are recycled; *situational prevention* is the label given by criminologists to the digital ordering of public space. Its implementation is supposed to diminish the feeling of insecurity, by cyber-regulating street space so that everybody's comings and goings, everyone's gestures, and, if possible, their thoughts too, remain under control. The number of public benches is reduced, or the seats are made discouragingly uncomfortable. Here and there, spikes are placed to stop you lying or sitting down. Transparency and the rationalization of flows are combined to make society more predictable and profitable and to keep "users" in a state of aesthetic privation or saturation, a sensory and existential impoverishment that is more easily managed. And so we pursue the mass hygienist tradition invented by the nineteenth century.

When Paris was rebuilt under Napoleon III and many streets were destroyed by Baron Haussmann to make way for wider avenues, there was a concern to contain threats of popular uprising, to make barricades difficult to build, to increase rent by renovating neighborhoods and thus push the working classes out to the suburbs. It was not just about managing traffic, but rather a form of social and behavioral engineering. It is not only about the need to anticipate problems, but rather to determine and

shape humanity, an instrument of power that Michel Foucault, author of *Discipline and Punishment*, called *biopolitics*. Statistics replace lived experience in decision-making. For those whose minds are being minted, navigating through urban space-time is no longer an adventure but a production of data for engineering. On the one hand, we produce increasingly aseptic central environments; on the other, we maintain the repressive contrast with the dirty, repulsive neighborhoods.

Our cities have two coin sides: one is the hard metal unit, the other is the wave. The neon signs scattered across the metropolis draw a semiotic skeleton in lines of light. If the city we live in seems no longer much more than a structural carcass or a functionalist machine, it is our task to put some flesh back on and revitalize it. This is what we have always done with reality, whether as a text or a grammar in which the verb and the dynamic of discourse give direction and body. Professor Louis Massignon, a specialist of mystical thought, believed that "consonants are the impersonal skeleton of an idea. It is only the vowels that can personalize and animate the mute skeleton."[2] The relationship between humans and technology could be analogous to the relation between vowels and consonants. The Arabic for "vowel" is *haraka*, which also means "movement." In several mystical traditions, vowels are the vital lifeblood flowing through the human arteries of hope, desire, hearing, emotions, mediations, and hubbub, without which the structures of reality would be a cemetery of bones and scaffolding. In 1871, a few years before he left for the East, the poet Arthur Rimbaud sang "A black, E white, I red, U green, O blue: vowels / I shall tell, one day, of your mysterious origins."[3] The alphabet is composed of sound and rhythm, and the opening of the vowels is the first euphony: in phonetics they are defined by the free movement

of air through the throat and the mouth, whereas the consonants obstruct the breath, while also giving rhythm, introducing Logos and structure.

"Everything is noise for the fearful," said Sophocles. Shakespeare's enjoinder is to "look with your ears." To escape from the imperial regime of sight, from the paradigm of light with its Platonic and plastic hierarchies, its dichotomy of being and not-being, we might need to start to listen again, to hear and realize something about the flow of unheard possibilities, and to listen more carefully to each other also. We might represent the world as a multidimensional spectrogram, the tracing of peaks and troughs of a polyphony of sounds and waves. The anthropologist Marcel Mauss wrote in 1934 about collective representations: "Our music is only one music. Yes, there is something that deserves to be called 'music.' It's not the music of our 'musical grammar' but this latter is part of it. The same holds for all the major orders of social fact."[4] Building a more harmonious society is a collective endeavor, a modulation of resonances, a tuning of assonance and dissonance, a poem.

In 1913, just as neon was newborn and the Futurists had just used the fluorescent gas to illuminate their names in the Parisian night, one of them, Luigi Russolo, wrote a manifesto, *The Art of Noise*. For him, the ear could explore the new soundscape of the city to "enlarge and enrich more and more the domain of musical sounds."[5] The ear should pay attention to the noises and their infinite variety, so that hearing might overthrow sight, so that the emotional response might be refreshed, even if it was necessary to break momentarily with the past. "We want to score and regulate harmonically and rhythmically these most varied noises. ... We feel certain that in selecting and coordinating all noises we will enrich humans with a voluptuousness they did not suspect."[6]

Many citizens navigate through public spaces with headphones on, in a fragile attempt to negate publicness, unpredictability, or communion. Radio killed the auricular stars. Our overproductive cities are making us into indisposed, half-deaf ruminants. Regarding urban sound, anthropologist Jacques Cheyronnaud wrote in 2009 that "political, social, health, moral and aesthetic questions of auricular management, focused on individual and collective well-being, private as well as public, are all concerned with producing a 'common placidity.'" This mass-placidity develops through local tensions, "pitting one party against the other, one accusing the other of 'making noise.'"[7] Nuisance noises are more often decried by citizens than visual pollution.

What is at stake is the possibility of social heterophony as a step toward a more symphonic society, the realization of a common hearing that is not simply the flat, fearful result of low-pitched consensus. Pluralist well-belonging would be about helping individuals to live together following their inner tempos and tonality because beings are not sensitive to the same frequencies. How can we hear again the sound of silence and the music of the spheres? Twenty-first-century politics should be acousmatic—an art of composers, orchestrators, listeners, choreographers, and choral intelligence.

Sonorous and spiritual emanations that are the flesh of our worlds, creative waves, vibrating elementary strings, diffractions of the infinite ether that the ancient Greeks called "eons": they are the reverse of the neon. *Eon* or *aiốn* (αἰών) in Greek means initially "creation" or "generation." It is a term used by Gnostic cosmogonies, in which we find a correspondence between an ideal world and the world of the senses. In *Timaeus*, Plato calls eon the eternal plane of truth, as opposed to the time (*chronos*)

CHAPTER 7

of the surface world. Whitehead called "eternal objects" these strange attractors of individuation. For the Gnostic followers of the mystic Valentinus, a second-century Neoplatonist and Christian, Wisdom is one eon among others, which seeks being but does not succeed in finding it. This Wisdom is eventually taken back to the divine by the Holy Spirit but, before getting there, will cry in the void for a while. Those tears give birth to our world. For Valentinus, the eons form a chain of intermediary beings between God and man. They are abstractions that become manifest in our world as embedded (and distorted) values, emanations of Wisdom, Faith, or Prudence. The allegorical figures on the façades of the Paris Mint are well and truly eons, yet another proof of the voracity of capitalism, which needs spiritual nourishment to consolidate its powerful regime.

In his 1969 text *The Logic of Sense*, philosopher Gilles Deleuze discusses the Platonist distinction between eon and chronos. Whereas chronos is the plane of history along which bodies materialize, eon is the untimely temporality of becoming, along which events and meaning are realized. It is the enchanted surface that hosts the miracles of our existence. The eon is the vibration that precedes identity, the eternal creative emotion, "the internal" eternal, the infinite line of the instant, a magical, virtual slate. Eons are not *realia* but *crealia*, the monads of the Creal.

Neon materializes the dialectic negation of the eon: the identity that attempts to stop becomingness. But neon can also be a crealectic stage for the necessary compositions that prune the invisible by shaping the outlines of lived experience, distinguishing beings separated from each other but also worlds in which they can dwell. Ideals are temporarily embodied. When Deleuze asserts that cosmologically there is "neither one nor many," he is evoking the clamor of the eons, the sonic, undulatory aspects

of the Creal, the metamorphic matrix of beings. But he is also aware that pure multiplicity is only possible virtually. The universe is a love story between asymptotic multiplicities and quasi-units. Deleuze writes that "the univocity of Being" is a "disjunctive synthesis."[8] The transition from the Creal to beings, from crealia to realia, is a provisional mutation of sound into a visible matter, from wave to particle, gas to light crystal: provisional because the path in reverse remains possible. Deleuze notes that our worlds are made of lines.[9] These lines are neontic. Without these asymptotic borders, nothing would exist as representation—and perhaps not even as presentation. The Creal would never create any reality. The panphony of the universe would have no listeners.

Effective policy needs to become a human musicology. Then perhaps the prostituted soul of Paris will move out of the mint building, which openly boasts of practicing the black magic of "metaLmorphosis." But before we accuse money of all vices, it is important to understand what its universal circulation has done for the progress of cognitive freedom.

Descartes penned an unfinished treatise entitled *Search for truth through natural light*. In it, we find this concern, again linked to the metaphor of light, to free oneself from the influence of external authorities. Descartes writes about the utility of common sense and methodical clarity: "This is what makes me hope that the reader will not be upset to find here a more abbreviated way, and that the truths that I will advance will agree with him, although I do not borrow them from Plato or Aristotle, but that they will have value by themselves, like money that has as much value whether it comes out of a peasant's purse or the treasury."[10] We detect here a sociohistorical source of the idea of autonomous individual reason: the extension of the possession

of money to pockets of the third estate. From the Middle Ages onwards, it was the so-called merchant classes—that is, those who were not aristocracy or clergy—that became progressively richer. They began to accumulate wealth through commerce, and the universality of money (its common value and wider circulation through all types of purses) gradually spread the awareness that there could also be universal thought. If my coin, my banknote or letter of credit, fruit of the labor of my body or cleverness, has the same value as your coin or note, then why would my judgment, fruit of the labor of my reason, be less valuable than yours? The natural light of Cartesian reason is modeled on pecuniary abstraction.

We find it difficult to give up the reign of money because it has contributed to forging our modern freedom of conscience. The rediscovery of conceptual abstraction and independent reasoning by the middle classes during the Renaissance, through and beyond the numerical equality of currencies, ushered in a conditioning that was to last. Fiduciary money relies on *fides*, Latin for "trust" or "confidence." If I accept a payment in banknotes for a job, it's because I trust that I will be able to exchange these notes at a later stage for other goods or services. The origin of capitalism is a circulation of trust and standardized units of value, which eventually promoted, among other realities, abstract thinking. The links among the fiduciary value of money, its extension to the middle classes, and the power of reason (*ratio* in Latin also means "account" and "proportion") contributed to gradually discredit aristocrats as mental degenerates, as their lifestyles pushed them to spend without counting instead of meticulously hoarding like the bourgeoisie. Rationally, from the bourgeois perspective, throwing money out of the window amounted to a madman's complete dispersal of

the most diverse opinions and ratiocinations. The new subjectivist economics also meant that disinterested donation and luxury had to be more controlled. Money earned by the sweat of your brow brings with it some prudence and parsimoniousness of the same kind we find in the work of analytical—Freud would say *anal*—thought.

In speaking of the peasant's purse, Descartes felt that there was a link between "agriculture" and "spiriculture": the spirit would be seen as a field or plot, a Cartesian coordinated space to be tilled parsimoniously and planted with seeds to be harvested later. Once he has become worldly-wise, Voltaire's Candide tells us that "we must cultivate our garden." In this respect, capitalism's current crisis is linked to the dissociation of labor from money through financialization and the advent of a delirious new financial aristocracy who tend to forget about service, prudence, and reason.

Imagine a neon sign that would flash "Hotel," and the minute after, "Comédie française," then "Sex Shop," and suddenly "University." Such a sign would be quite useless and seem dysfunctional, fallacious, or comical. If someone changed language every day, making up new words and phrases along the way, without reproducing the same syntax, we would think him a madman lost to society. It is difficult to establish a society without a value system based on an identity of values—that is, X today will be X tomorrow; only then, through commonly agreed-upon social contracts, can things develop or be changed. Such permanence of values is daily shaken by financial speculation, which creates an artificially unstable, superficial world of caprice. The current volatility of the markets is the stock exchange version of arbitrariness. It creates a general atmosphere of anxiety many of the nontraders sense in their chest. Caprice in children is both annoying

and charming; in adults with suits and ties, it can feel scandalous. Wall street traders are not so much greedy as they are irrational.

One winter Sunday, I went for a walk in the Fausses Reposes Forest, which was covered in snow. I took a little detour to the cemetery at Ville-d'Avray, along the edge of the wood. The avenues between the trees were coated in a thin layer of white, and I played at following the traces of steps between the tombstones. Why are we so attached to footprints? Are they not proof that the body that printed them in the snow is a ghost that passed by? Why is the idea of *anonymity* slightly disagreeable? Etymologically, it is "without a name" and therefore suggests the desire to have a name. The twentieth-century mathematical society Nicolas Bourbaki and the recent activism of the Anonymous movement give good examples, among others, of what a group can achieve when it relinquishes the obsession with egocentric individuation. They focus on the integrity of common values and the loyalty of esprit de corps. We are often so self-obsessed that we forget to consider that "soul is anonymous," according to the thirteenth-century mystic Master Eckhart.

What is a crealectical social creation? It is the participation of the Creal in the creative emotion and craft of individuals connected in a web of beliefs and in a chain of realizations. An industrious emotion at once personal, collective and impersonal, internal and external. It is my emotion, and in this sense I can say that I belong to a subjective consciousness, but at the same time it connects me to otherness. This is the paradox of the universe: the creative emotion, as a *locus* of the universe, elicits an impression of separation and belonging at one and the same time. This duality is at the very heart of the dynamic of creation.

Our nocturnal dreams, both impersonal and personal, are the best way to understand what co-creation is about. If we wish to

avoid becoming robots and the anxiety that social codes impose on us, we can practice a discipline not so far removed from that of the lucid dreamer. In 1867, Victor Hugo wrote: "The one who dreams is the preparer of the one who thinks. The achievable is a stone that must be sculpted, and it is the dreamers that begin its shape. ... The first phase of the possible is to be impossible. How much madness is there in a fact? Thicken all dreams, you have reality. An august concentration of utopia, similar to cosmic concentration, which from fluid becomes liquid, and from liquid becomes solid."[11]

What is a city—a *polis*? It's a world, a network of actualizations and realizations "knotted" together to define a territory that is more or less shared, shaped by discourses, symbolic crystallizations, viscous ideological grammars serving the interests of temporary groups and forming a bulwark both against external turbulence and internal ambitions. Different ways of manufacturing human neon. The hyperrealist prejudice has it that on earth today there is only one just about coherent world—that is, the "capitalist-humanist" system, which strikes a delicate balance between maximizing financial surplus value and controlling empathy. In the capitalist-humanist system we endure, our suffering is explained in terms of capital and humanism: money and human nature operate as a reassuring or worrisome duo and are the key to a monotonous universal understanding.

Many humans prefer to suffer in a familiar and consensual frame of reference rather than adventure into their fear of new perceptions. In sociology, the so-called Thomas theorem attributed to William Isaac Thomas in 1928 has it that "if humans define situations as real, they are real in their consequences."[12] No matter what neoconservatives would have you believe about universal archetypes and the perennity of human

worlds, social reality is not true in itself but to a great extent a slowly built construct of epochal convention. A city-polis, a social structure is all the result of a common understanding and daily reconducted agreement, drawn from among an infinite number of possible interpretations and configurations. As the earth becomes globalized, alternate possible words seem more difficult to establish sustainably; such is the paradox of laissez-faire that it produces mimetism.

If a majority agree in believing that capitalist-humanism is the least bad of systems, then our actions will converge to validate and realize this belief: particular rites of passage will be repeated—for instance, considering money to be the means of universal exchange. Karl Marx wrote about this in his 1844 manuscripts: "By possessing the property of buying everything, by possessing the property of appropriating all objects, money is thus the object of eminent possession. The universality of its property is the omnipotence of its being. It is therefore regarded as an omnipotent being. Money is the procurer between man's need and the object, between his life and his means of life. But that which mediates my life for me, also mediates the existence of other people for me. For me money is the other person."[13]

A comprehensive approach to Thomas's theorem is not complicated: everyone knows from experience that our habits shape reality. It's part of what we call the *force of circumstance* in common parlance. At the level of society, a new convention always takes place in a system of conventions that precedes it. If the new convention is too far removed from its basis of application, it will have some difficulty in generating reality. This is why social creation or societal renewal is a slow, viscous process and radical individual creation even more difficult. For Thomas's theorem to conform more closely to experience, we

need to reformulate it as follows: If humans define a situation as real and this definition is not too far removed from the definition previously agreed on by most people, then the definition can in the midterm become real in its consequences. Let's take the representation of a wave function of a violin string on a horizontal and vertical axis: in general, modulations are curved. As the physicist Leonard Susskind explained, a vertical rise of the wave function would mean that the string breaks. To change reality, you cannot attack it vertically, because it will break you faster than you manage to break it. There is always an element of compromise in real social change. The world becomes sometimes what a dedicated group admires, but it takes much skill and time. Only in simplified history books can revolutions be given a fixed date like 1789. In reality revolutions are evolutions.

What is the difference between identity and integrity? Integrity means that what we are capable of renouncing for the sake of our spiritual unity edifies and makes us more whole in the midterm. Of course, it's likely that no individual or group has ever attained or will ever attain complete unity, which is why integrity begins with a sincere tension or *intention* toward an ideal. Master Eckhart said that love makes us become what we love. Persistent love for the One makes us quasi-*one*, persistent love of the ontological multiple makes us quasi-creal, and with benevolence towards these two asymptotic horizons, we can see the outlines of a democratic polis which is neither totalitarian nor deliquescent. If we aspire to harmony, we need to know what to give up, along which lines to travel, so that self-restriction is fertile rather than deadly.

This is absolutely not a matter of revisiting hardcore puritanism, which would be as unhealthy as big-box shopaholic

hedonism. Integrity is the aspiration of the person or collective who wishes to write her own symphony from crealectic riches and day by day jots down the notes. Integrity is to fold the chaosmos with thoughtful intent, following a fervent path towards a flexible but beautifully set idea, claiming that this crease is one way among others, one style, one hope. Integrity is the gathering structure around a particular tonality, self-critical and modulated, the passion of destiny incarnate, always alert to the possibility of changing its tune.

Hegel wrote that "reading the morning newspaper is the realist's morning prayer. One orients one's attitude toward the world either by God or by what the world is. The former gives as much security as the latter, in that one knows how one stands."[14] Often, when we are dependent on the neon signs of the media, we embrace a vision of the world presented as simple consumer choices so that we can constantly archive identities—neon is neon, a migrant is a migrant, reality is reality—and move on to something else, without always having the time to listen deeply. Every morning, mainstream media implicitly define what is real and what is not real and therefore what is possible and not possible. Hegel implies that nothing makes sense for us without a belief system and that realism is a religious cult conveyed by the dominant media. Reality is the glass of the neon. In much the same way that fiduciary money has been as much liberating as it has been perverse, more recently neon light hid within itself a fertile contradiction: gas, according to Deleuze, still has a "free path."

In "The Eye of Power," Foucault reminds us that "a fear haunted the latter half of the eighteenth century: the fear of darkened spaces, of the pall of gloom which prevents the full visibility of things, men and truths. ... It was the dream that

each individual, whatever position he occupied, might be able to see the whole of society, that men's hearts should communicate, their vision be unobstructed by obstacles, and that opinion of all reign over each."[15] This ambiguous state of antiopacity, defended in particular by Bentham or Rousseau, seems to have become our reality, enhanced by the development of the internet, surveillance, and globalized vigilance. But behind what might seem, from a negative point of view, the spreading of exhibitionism and a form of tolerant intolerance, there is nonetheless the outline of a Rousseauist utopia: shared honesty. Is this enough to create a shared cosmology?

When beggars die, there are no comets seen;
The heavens themselves blaze forth the death of princes.
—William Shakespeare[1]

NEON IN SPACE

The giant novelist Balzac wrote that our terrestrial capitals are "in perpetual turmoil from a storm of interests beneath which are whirled along a crop of human beings, . . . whose twisted and contorted faces give out at every pore the instinct, the desire, the poisons with which their brains are pregnant; . . . There all is smoke and fire, everything gleams, crackles, flames, evaporates, dies out, then lights up again, with shooting sparks, and is consumed."[2]

Let us now suppose the existence of a celestial cosmic city—more real than the real. Let us harness the gods and science to transport us into outer space. Researchers are now using this gas that is neon to unravel the mysteries of extrasolar matter and that which is beyond our galaxy. Reading David McComas, principal investigator of the Interstellar Boundary Explorer (IBEX) in San Antonio, Texas, we understand why this element is used as a standard of measure: Neon is a noble gas, unrelated to any other element. It is relatively abundant, so we can measure it with significant statistical frequency.[3] In the solar system, for every 20 atoms of neon, there are 111 atoms of

oxygen. Outside our system, neon is proportionally more abundant. Why? This is still a mystery of physics, a science that for a century now has been producing poetically and philosophically fertile visions of the world.

String theory, for example, which has emerged over the past seventy years, is considered by some as a return to the inspirational Pythagorean harmony of the spheres. It holds that the universe is fundamentally composed of minuscule vibrating filaments. Gabriele Veneziano, Joël Scherk, and John Henry Schwarz were among the pioneers of this cosmological vision based on complex mathematics and on the apparently simple idea that everything is sonic, undulatory, and concerted. The universe—or the multiverse, as string theory supposes many dimensions and perhaps parallel universes—is well and truly a *panphony*, a symphony of all there is.

The raw material of the universe is vibratory effervescence, entropic turbulence, or, to borrow physicist John Wheeler's term, *quantum foam*. But on earth, things get more complicated: we witnessed the emergence of beings who express themselves in the first person and, despite chaosmic disintegration, feel (more or less) individual. To explain the world, we cannot be content with an image of flux and vibrations; we have to explain how particular and conscious bodies take shape, how beings are constituted, and why there is integrity and observers.

Etymologically, *integrity* designates *purity*, an unblemished character that has not been mixed, soiled, or altered. In this sense, the integral would be the whole, one, entire, not disparate. The attribute *integrity* could be assigned to a body, structure, or entity that has not been *integrated* by and into exogeneous elements. Yet this notion of integrity as original inviolability might seem naïve. The coherence of a body, an idea, or a group is the

result of a more or less transient equilibrium, wrested from turbulence, probability, or will, never permanently acquired. Are we not bisected by cosmic rays, vital overabundance, and stirred up by the stormy chaos of encounters we are made of? If we take only the example of light, composed of quanta of photons, then each cubic meter of the universe, including the one our body occupies at this very moment, contains on average four hundred million photons, which compose the vast ocean of microwave radiations.

Richard Feynman, Nobel-prize winning specialist of quantum mechanics, developed the theory of *path integral formulation*, in which an event is the result of the summation of all possible paths. When we observe the movement of large objects on a nonchaotic scale—for instance, tennis balls, pianos, or planets—all the possible outcomes cancel each other out, except for one—and even this *one* is an asymptote, a valence that a being approaches indefinitely without ever coinciding entirely with the limits of a pure identity. Being one is before us and pulls us into becoming, whereas the Creal pushes. We might say of a person that she is *integral* when she behaves coherently—that is, when she is loyal to an axiology, a microsystem of principles, an internal sense of rightness, or a motto. People are *integral* if they aim to be honest with themselves, which does not necessarily mean accommodating others. There is a becomingness of integrity for she or he who subordinates the apparent hubbub of the cosmos to their own tempo. Human integrity is a constant discipline, a martial art, not a given.

When we realize that the multiverse is not going anywhere in particular, that it is constantly transforming while leaving space for local edification, we are made to face up to our own desire, to responsibility, to the ever-changing possibility of individual,

political, and social renewal. Crealectics, the philosophy of futuration, will look at solutions that respect the exceptions that configure the rules. Integrity is a filter, a style, a motto, an iterative truth, a magic spell, an act of self-legitimation or self-institutionalization that must be tested over and over against reality. The capacity to *crealize* reality—that is, to orchestrate the waves, to help crystallize vibrations—is not evenly distributed over all points of the multiverse: the greater the integrity of a system, the stronger its ability to be perceived as real.

One of the remarkable aspects of twentieth-century physics is its gradual relinquishment of the determinism or reductionism that paradoxically helped develop it. Not only astrophysicist Edward Witten, father of M-theory (which prompted the second superstring revolution), but also Stephen Hawking, and an increasing number of cosmologists, dropped the idea that the history of the cosmos was written in advance, predictable and capable of being reduced to objectivist observation. Some scientists now aim to include the principle of permanent renewal in their descriptions of the cosmos. Why should we start by postulating propulsive, scattering multiplicity as the sonic flesh of the universe, rather than comfortably relying on a logical order set once and for all by a divine master watchmaker? This is also an ethical intuition, linked to a desire for the freest possible humanity. Now what cosmology needs to correct and consider as its major challenge, is the reintroduction of the observer into the description of all there is.

Originally, there were no beings in the universe, nor the relative fixity of an ordered world, but a vibrating multiplicity, essentially invisible to humans. The chaosmos is at every instant original, yesterday, today, and tomorrow. I proposed to call it *Creal* to insist on its qualitative and quantitative creativity.

Process-oriented philosophers like Heraclitus, Whitehead, Bergson, or Deleuze also say that at the beginning there is a disparate becomingness and an immanent wealth. A deterministic social physics would make us the automata of causality. By entering into the public domain in the nineteenth century via the Romantics and science, the idea of immanent creation secularized the ideas of natural chaos and human ordination. Social order has become our responsibility and is no longer the preserve of religion.

The hypothesis of flow over substance is supported by one century of developments in physics. It also seems reasonable and harmonious from an emancipatory political viewpoint. The paradigm of creativity is more desirable to facilitate a fairer society than the determinist vision. The creal process designates the logic of the multiverse, an infra-animal, immanent profusion, an incessantly renewing protogas of vibrations. The Creal is like the prime mover of Aristoteles, the medium of all actualizations, the as yet unformed form of all shapes to come, the antechamber of every possible. Creal becomingness is always vaster and richer than what we see and perceive of it. Many astrophysicists claim today that we only understand a tiny proportion of the universe and that the rest is made up of "something other," something more mysterious and less embodied, an expanding force.

However, as explained by mathematician and philosopher Alfred North Whitehead, a "world" is not pure creativity, but a society, a local form given to the chaosmos, a realizable structuring among others of the vital explosion, a *creorder*, to use the term coined by Jonathan Nitzan and Shimshon Bichler in their book, *Capital as Power: A Study of Order and Creorder*. There are several possible worlds. Philosopher David Lewis defended in

his modal realist theory that many possible worlds exist, and not just in imagination. A crealectician stops adapting at all costs to the ambient reality even if it is considered to be analogous with truth. Instead, she carefully takes hold of the reproduction of reality, encountering difficulties and taking wrong turns, but making the future respond more, if not wholly, to her vision and the vision of her community.

Is it the universe (the multiverse) that creates, or do humans create? This question carries perhaps a dualist error in separating humans from the creative continuum. In 1929, Whitehead came up with the neologism *superject* to grasp the spirit of a living structure, an organized instance of becoming. Let's imagine the vital explosion of chaosmic turbulence, which has no reason to be homogeneous. It is infinitely more likely that some of its jets of energy, some of its vibratory strings and projections, are more dynamic than others, momentarily. Some parts of the creal explosion are moving more quickly and densely, and are therefore more attractive. Some vibratory filaments—*crealia* rather than *realia* or *qualia*—phase together around a particular frequency and form a node. Each vibration has its frequency and speed and entails different dimensions depending on whether these are high or slow. Some waves have more energy, more inertia, and, if we believe Einstein's principle of equivalence between mass and energy, speed, and gravity, they attract and take with them part of their near environment. An order, always local, realized and provisional, is the effect of an always temporary subordination of minor subjects to dominant superjects and has the capacity to influence a composition, like musical tonality ordering a sonata. In our societies, the superject, a strange attractor, is not necessarily a flesh-and-blood individual, but more likely an idea, a group, a context, a collective arrangement or social body.

"Each occasion exhibits its measure of creative emphasis in proportion to its measure of subjective intensity," wrote Whitehead.[4] But how are we to define this subjectivity? This is where the notion of integrity comes into its own. The more the local superject attracts and incorporates less dynamic elements of the creal multiverse, the more it feels intensified and distinct and aspires to increase the perception and perfection of its unity. It can persevere in its being by building irrigation dykes, bulwarks against its dissolution, and by asserting a number of axial impressions. The superject is the (attr)actor of wave propulsion and feels the crealectical tension of absorbing alterity while aspiring to homogeneity. In other words, the "dividual" or even the "multividual" aims to become the "individual." But the individual also knows that it must refresh itself by diving regularly in the Creal so as not to wither away.

This may seem like a preliminary sketch to legitimate the ascendancy of vital force over the social order. If the dominant form of moral virtue is a spurt of pure vitality and if some people dominate because they are both pushed by the power of Creal and pulled by the power of One, does this not lead to renouncing egalitarianism and to returning to innatism, to the doctrine of predestination, or just another way of absolving the rulers and exculpating the hegemons? Would a dynamic, physicalist conception of integrity not usher us back to Nietzschean supremacy, to admitting that particular individuals need do less to conjure up what would be their intrinsically legitimate power and harmony?

Actually, the unity of the superject is probably not achieved by kinetic energy alone. Rather, the wantonness of propagation is as likely to give rise to divergent ramifications. Power alone is not enough to become integral; it is very much a matter of remaining as unified as possible through a constant effort of

spiritual purge, a discipline of listening, hearing, and understanding. Not all nourishment feeds individuation. There is integral power and social power. The latter may be a perversion of the former—and even its momentary negation. Some souls only reach social power once they have lost their integrity. Others are too immersed in the Creal to even seek or be able to obtain approval.

There is no integrity without self-limitation, without self-discipline, without tenacity or resistance, in the same way that there can be no musical composition without a certain tonal protocol. The stronger the thrust of the superject, the more difficult it will be to channel its integrity away from self-annihilation. It is not only the explosive force that is powerful. The crealectician does not directly aim to dominate others, but first to achieve a harmonious, open mastery of self and respectful dialogue with the Creal, however ambitious that may be. If many are living mostly on the neon plane of subsistence, some try to spend as much time as possible on the eon plane of eternity. Real being is neonness. Creal being adds eonness.

Crealectics is about cosmopolitics and vigilance. To Heraclitus's aphorism, "Everything flows," we might add, "Everything is hearing." To persevere in being and constitute society in their likeness, human superjects must fight the explosion, noise, and cacophony that swallows them from inside by rallying, collaborating, composing, sorting, naming, excluding, purifying, pruning, trimming, and edifying with all the various tonalities possible. Rather than an overcompartmentalized economy or ecology (the prefix *eco-* comes from the Ancient Greek *oîkos*, for "house" or "household"), crealectics is indeed an *echonomy*, a culture of composition in which hearing is healing, a living practice against disintegration and fundamentalism.

Twentieth-century philosophers described the motivation for the ubiquitous impulse to create in terms of "lack" or of a "principle of disquiet," a "desire for actualization" partly acknowledging the intuitions of Spinoza and the mystic Jacob Boehme, for whom desire was the essence of creatures. We may talk about a *conatus*, an effortful craving or appetition, when referring to subjectivity. But when we describe the Creal, Lacanian jouissance seems a more accurate analogy. In Lacan's seminar XVII, we read: "This is why the only chance for the existence of God is that He—with a capital H—enjoys, it is that He is jouissance."[5] Lacan called this absolute *the Real* (forgetting its creative nature). Buddhists call it *the Void*. On the plane of cosmic panphony, the Lacanian God is an infinite, spiritual orgasm beyond good and evil, pure ecstatic enjoyment. Undoubtedly, in olden times philosophy was rather more chaste: in the eighteenth century, for example, Kant preferred to forbid knowledge of the absolute rather than admitting it was about sensual exhilaration (*hilarós* in Ancient Greek can mean both "cheerful" and "propitious"). In the crealectic process, the source of reality is exhilarating, vibrant, quietly joyful, and rooted in overabundance. Sadness is the local negation of cosmic joy and melancholia the nostalgia of pure Oneness. Neon signs are deeply melancholic.

But we need to return to the question of why exhilarating chaos does not simply remain chaos. How do we explain that some spaces of life, and not only human spaces, show signs of organization? A simple answer would be to say that in psycho-analytical terminology, jouissance is distinguished from the pleasure principle. "This is what is known as the principle of pleasure. Let's not stay there where one enjoys, because God knows where it might end."[6] When the superject allows itself to be absorbed into ubiquitous jouissance, when it renounces

self-mastery to respond anarchically to the call of the vibratory absolute, the individual dissolves again, risks incoherence or loss of subjective integrity. Conversely, too much will to mastery also leads to self-destruction via morbid rigidity. Any type of organization is a defense against the craziness of creal motion, as well as a manifestation of the longing for unity that is constitutive of the universal duality. The Multiple presupposes the One logically and ontologically. There is One and Multiple or, better, Quasi-One and Quasi-Multiple because the chaosmos is a dance of polarities, as Heraclitus and Hegel intuited. For there to be a multiplicity, we must *logically* accept the idea of unity, although the total unity of the chaosmos never really takes *place*. We could not say "this is many" if we did not conceive of the idea of One. Unity and symmetry are the logical horizon drawn by any creal profusion. Disorder is inconceivable without the notion of order. Beavers build dams, termites build castles, humans devise grammars and social codes, all to avoid having the Creal dissolve identifications, extinguish our neonness, pulverize the crystals of reality that solidify and articulate the waves into discourses and territories.

Spinoza urged us to consider what a body could really do, suggesting that it could do much more than usually believed. A body is capable of finding a fruitful equilibrium between the line of flight and the line of reality. Here we can remember the Nietzschean distinction between the Dionysian and the Apollonian. Apollonian integrity is that subjective moment when life resists splintering by asserting a legitimacy, a local law or particular perspective, in which the will to coherence and to the projection of one's own inertia into reality seeks to dominate Dionysian exhilaration. The very fact that consciousness conceives the idea of unity makes it universal. Unless we

separate language from reality, we must accept that what is logical is as real as the physical. Ideas are beings in the universe in the same way that black holes are. The observer is part of the observation.

Local individuality is that energy-bearing, ordering part of the Whole which wishes to persevere with the unification and purification of its being and to fold its environment into its own density and tonality, thus evoking the "strange attractor" of quantum physics. The cosmic "I feel" of the superject happens at the point where a part of the Creal refuses and resists dissolution, is nostalgic for the ghostly One that is its projected shadow. This is where we can make out the formation of a primitive "I," a protosingularity, a field that slowly becomes a lyric plea. The Creal is epic, the One is lyric. Little by little, this creal spurt becomes self-aware, building on the emotion by which it is created and the impressions that refine it and give it structure and unity. Crealectics perceives itself as coherent resistance to splintering, belief in the achievement of a singular composition, and respect for the creal forces that dynamize the unifying principle. We must be aware of our ambiguous desire to overjoy—that is, to climax in creal jouissance. Ambivalence creates what philosopher Gilles Deleuze calls the "crack-up of the I." We are made of three asymptotic lines, the line of Creal, the line of One, and the crack-up line designed by the pression between the two former lines—a crack-up that can be ascendant (self-realization) or descendent (depression). Lacan suggested that the moment of anxiety is precious as it reminds us of ourselves, of the meeting point of our desire to become integral and our impulse to explode.

From the point of view of the Creal, integrity as unity and coherence is sublime: it is the Other, pure coherence, pure adunation. From the perspective of the One, the Creal is sublime:

it is the other that explodes in climactic overjoy. The primordial couple of Creal and One is entwined in a multiple becoming of worlds and particulars, flesh and spirit, solidity and solidarity. Ontological passion meets tragicomic symphony. Here we can hear the echo of Heraclitus, who "says that the universe is one, divisible and indivisible; generated and ungenerated; mortal and immortal."[7] Individuals are eontic and neontic at the same time, a tense between the chaotic gas of multiplicity and the ordered glass of unicity.

Humans, as children of the chaosmos, aspire to unity as much as they aspire to diversity. This obviously has political implications, whether you happen to lean to the left or to the right. A concern for cosmological coherence and a determination to apply this coherence in the political sphere seems more useful than pure relativism or a managerial vision of reality produced by analytical accounting. Nihilists are atrophied superjects whose diminished vital force makes them less aware of the fullness of the Creal. Deleuze calls them *damned souls* because instead of dilating into vibratory lines they tend to become a concentrated point of tired intolerance for the multiple. As social subjects, often *too social*—that is, tending to naturalize the order in which we live and to confuse local reality and truth—we all have our more or less nihilistic moments. No order can claim to be ubiquitous without fatiguing our openness to creal becoming and therefore creating vacuums of anguish where there should be lively differences and fertile potentiality. Heraclitus again: "If you do not expect the unexpected, you will not find it."[8]

Open integrity is musical, a two-part refrain. It's about harmonizing tenacity and remaining childly open to creal wealth. For Deleuze and Guattari, the refrain or *ritournelle* designates a

territorializing axis of individuation, the existential ascending motto, how persistence enchants the subject to resist abolition, resists either dissolving like a gas or crystallizing like a glass. The somebody—you and me—is never quite as docile as a light sign. We are permeated with the vapors of the Creal, sometimes perturbing, sometimes delectable and stimulating. We are not just neon lights; we are also eon fights.

Sounds are reborn through times without memory.
—Pierre Schaeffer[1]

FINAL CHORDS: THE BARS OF LIGHT

A year after the events of May 1968, in Martin Malburet's Parisian art gallery, artist Michel Journiac staged a work entitled "Trap for a voyeur,"[2] which was revived more recently in 2011. Mixing installation and performance, it consisted of a cage of fluorescent tubes with a naked young man enclosed inside; his job was to undress visually the visitors who caught his eye. On both sides of the neon prison, the human became a naked voyeur. As our critique of neontic reason draws to a close, it might seem that this artwork manifested a dangerous trend in the psyche of the twentieth century. Perhaps, after all, this installation was a commentary on the supposed failure of May 1968. But let's be more optimistic: if the bars of light are read vertically, they are indeed a prison of transparency; but if we rotate them ninety degrees, they become the horizontal steps we can climb to explore the unheard regions of our cosmos.

At the end of *Being and Nothingness*, Sartre writes that "the moral agent ... is *the being by whom values exist*. It is then that his freedom will become conscious of itself and will reveal itself in anguish as the unique source of value and the nothingness by

which the *world* exists. As soon as freedom discovers the quest for being and the appropriation of the in-itself as *its own possibles*, it will apprehend by and in anguish that they are possible only on the ground of the possibility of other possibles."[3] The Creal is this ground of the possibility of other possibles. Once you're lovingly and emotionally connected to it, the neon sign of your social persona will regularly change shape. You will be less identifiable perhaps but in the end more overjoyed as a human.

The distinction Deleuze and Foucault drew between a disciplinarian and a controlling society is well-known. The first is governed by the principle of panoptical surveillance, with architectural and administrative apparatus designed for the surveillant to see without being seen and in which light is shone on those surveilled. In the previous era of societies under the supreme rule of a sovereign, the light was shone on the source of power—for instance, the Sun King, *Augustus Rex*. In a society of control, awash with artificial photons and electrons and obsessed with transparency, everybody surveils everybody else via screens of light. Globalization standardizes perceptions, identities, and mental structures in a vast, planetary open grid flooded with overly raw clarity. Hyper-transparency and overexposure are bothering the poet. Monotony is not only an impression, it is a production. Yet the cunning of the cities of light—akin to Hegel's doctrine of the cunning of reason in human history—was to use neon signs, among other devices, to spread a thirst for freedom around the world. Gaseous, chaosmic, creal vibrations trapped in glass tubes sing hymns of slavery, the echo of which can induce a new step toward liberation.

In the twenty-first century, the material matrix of crystal and light that covers the planet might explode. The detonation will

unleash a creal sensibility that will fill the world with music and effectual pluralism. Encapsulated in every neon light, in every material creature, there are sleeping eons, the possibility of spiritual recreation. We are not only embedded in ecosystems, but also in technosystems and noosystems. Considering a simple technical object such as a neon sign has allowed us to reflect upon ourselves because the cosmological unifying principle is the essence of technology. *One* is no more artificial than *Many*, but it becomes artificial when forcing a creal multiplicity into silence. *Many* is as fundamental as *One* and a pluralistic society should respect both the integrity of local aspirations to unity and our vital need for recreation. In order for our ecosystems and technosystems to be harmonized into nontotalitarian systems of knowledge and fore-knowledge, a global social contrat is now needed, based on the absolute axiom of creation, the shared cosmology of the Creal.

When Pythagoras died, a victim of a political conspiracy, the members of his sect, who were condemned to exile, split into two groups. The first were the *mathematikoi*, who devoted themselves to studying the mathematical laws of the universe—that is, to making calculations. The second group called themselves the *acousmatikoi*: *those who listen*. But what did they hear? What was the secret they shared? Why did they believe their knowledge was more important than mathematics? Given the huge role that mathematics was to play in human evolution, we can wonder whether the choice of the other half of Pythagoras's supporters was foolish or even more radical.

We must free ourselves from the excessive worship of sight and light, of all the discrete lights that illuminate, distinguish, and simulate fetishes. We need to rediscover, as twentieth-century physics started to do and as the ancient acousmaticians already understood, that everything is vibration, sound, and perhaps

even word or text. Ecology must become an *echology*, a science of listening and hearing.

In the nineteenth century, the poet as seer of illuminations—Rimbaud, for example—announced the age of electric light. Today, the crealectician must be a harmonist.

Oyez! Oyez! Oyez!

NOTES

PRELUDE

1. Victor Hugo, *Les Misérables*, in *Œuvres completes*, volume 3, book 1, chapter 6 (Paris: Ollendorf, 1913), 18; excerpt translated by Michael Wells.

2. Heinrich Heine, "Letter of February 10, 1832," trans. Charles Godfrey Leland, in *The Works of Heinrich Heine* (London: Heinemann, 1892), 75.

3. Charles Baudelaire, *Salon de 1846* (Paris: Lévy, 1868), 79.

4. Deolinda, "Que Parva Que Eu Sou," music and lyrics by Pedro da Silva Martins.

5. Jean Baudrillard, *The Consumer Society: Myths and Structures* (London: Sage, 1998), 26.

1 THE LETTER AND THE NEON

1. Jean-Paul Sartre, *Being and Nothingness*, trans. Hazel E. Barnes (New York: Philosophical Library, 1956).

2. Boris Vian's book has been translated three times into English, under different titles. Stanley Chapman's translation was titled *Froth on the Daydream* (London: Rapp and Carroll, 1967).

3. Sartre, *Being and Nothingness*, xlv.

4. Barbara Puthomme, "De quelques chemins qui mènent à l'art contemporain," *Philosophique* 9 (2006): 133–143, http://philosophique.revues.org/112.

5. Amah-Rose Abrams, "Minimalist Master of Light Dan Flavin," Artnet News, December 2, 2015, https://news.artnet.com/market/minimalist-master-light -dan-flavin-374936.

6. Guy Debord, "Introduction to a Critique of Urban Geography," *Les Lèvres Nues*, September 6, 1955, trans. by Ken Knabb, http://www.cddc.vt.edu/sionline/presitu/ geography.html.

7. Désiré-Constant-Aimé Hémet, *Traité pratique de publicité commerciale et industrielle: Le mécanisme de la publicité avec diverses applications* (Paris: Editions du Bureau Technique La Publicité, 1922), 163.

8. Philippe Artières, *Les enseignes lumineuses: Des écritures urbaines au XXe siècle* (Paris: Bayard, 2010).

9. Rudi Stern, *Let There Be Neon* (New York: Abrams, 1979).

10. Tristan Gaston Breton, "Georges Claude et l'air liquide," *Les Echos*, August 13, 2003, https://www.lesechos.fr/13/08/2003/LesEchos/18966-104-ECH_13-georges -claude-et-l-air-liquide.htm.

11. Sartre, *Being and Nothingness*, xlvii; italics in original.

12. Ibid.

2 AUGUSTUS REX

1. Pierre Bourdieu, *Distinction: A Social Critique of the Judgement of Taste*, trans. Richard Nice (Cambridge, MA: Harvard University Press, 1984), 252.

2. Raoul Vaneigem, *Traité de savoir-vivre à l'usage des jeunes générations* (Paris: Gallimard, 1967).

3. V. I. Lenin, *Collected Works*, vol. 42, trans. Bernard Isaacs, 3rd English printing (Moscow: Progress Publishers, [1917–1923], 1977), 280.

4. Clan du Néon, "Le traité fondateur," Overblog, July 2007, http://clanduneon .over-blog.com/pages/Le_Traite_fondateur-19863.html.

5. L. K. Fonken et al., "Influence of Light at Night on Murine Anxiety- and Depressive-Like Responses," *Behavioural Brain Research* 205 (2009): 349–354.

6. G. W. F. Hegel, *Phenomenology of Spirit*, trans. A. V. Miller (Oxford: Oxford University Press, 1977), 404.

7. Sartre, *Being and Nothingness*, lvi.

8. Johan Heinrich Winkler, *Die Eigenschaften der electrischen Materie und des electrischen Feuers aus verschiedenen neuen Versuchen erkläret, und, nebst etlichen neuen Maschinen zum Electrisieren, beschrieben* (Leipzig: Breitkopf, 1745).

3 SUBLIMISM

1. Michel Foucault, *The Birth of Biopolitics: Lectures at the Collège de France, 1978–79*, ed. Arnold I. Davidson; trans. Graham Burchell (New York: Palgrave Macmillan, 2008), 269.

2. Tom Wolfe, "Las Vegas (What?) LAS VEGAS (Can't hear you! Too noisy) LAS VEGAS!!!!," *Esquire*, February 1964.

3. Interview with Tom Wolfe in spring 1973, in the foreword to Rudi Stern, *Let There Be Neon* (New York: Harry N. Abrams, 1979).

4. Rem Koolhaas, *The Generic City* (New York: Monacelli Press, 1995), 1248.

5. Ibid.

6. Guy Debord, *Rapport sur la Construction des Situations et sur Les Conditions de l'Organisation et de l'Action dans la Tendance Situationniste Internationale,* trans. Michael Wells (Brussels: Internationale Situationniste, 1957), https://situationnisteblog.wordpress.com/2014/12/02/rapport-sur-la-construction-des-situations-1957/.

7. English translation from the Latin, by Project Pico at the University of Bologna and Brown University, http://www.brown.edu/Departments/Italian_Studies/pico/text/ov.html.

8. Didier Ottinger, ed., *Futurism* (Paris: Centre Pompidou/5 Continents Editions, 2008), 23.

9. Immanuel Kant, *Observations on the Feeling of the Beautiful and Sublime*, trans. John T. Goldthwait (Berkeley: University of California Press, 1965), 47–48.

4 THE INCALCULABLE

1. Martin Heidegger, "Hölderlin and the Essence of Poetry" (1959), trans. Paul de Man, in *The Paul de Man Notebooks* (Edinburgh: Edinburgh University Press, 2016), 44.

2. William Deresiewicz, "Generation Sell," *New York Times,* November 12, 2011, http://www.nytimes.com/2011/11/13/opinion/sunday/the-entrepreneurial-generation.html.

3. Ernest Hemingway, *A Moveable Feast* (New York: Scribner, 1956), 211.

4. M. Mauss, *The Gift: Forms and Functions of Exchange in Archaic Societies* (London: Routledge, [1925] 1990).

5. Martin Heidegger, "The Age of the World Picture" (1938), in *Off the Beaten Track,* trans. Julian Young and Kenneth Haynes (Cambridge: CUP, 2002), 72.

6. Ibid., 60.

7. Ibid.

8. Ibid., 61.

9. Ibid., 84.

10. Ibid, 66.

11. Ibid, 75.

12. Jean-Luc Nancy, *Being Singular Plural,* trans. Robert Richardson and Anne O'Byrne (Palo Alto, CA: Stanford University Press, 2000).

13. "The Age of the World Picture," 72; italics in original.

5 THE HALO

1. Victor Hugo, "Paris," in *Paris Guide* (Saint Julien: Arvensa, 2014), 37.

2. Charles Baudelaire, "XLVI, Perte d'Auréole," *Petits Poèmes en prose*, in *Œuvres complètes de Charles Baudelaire* (Paris: Lévy, 1869), 133–134; excerpt translated by Michael Wells.

3. Karl Marx and Friedrich Engels, "Manifesto of the Communist Party" (1948), https://www.marxists.org/archive/marx/works/1848/communist-manifesto/.

4. Walter Benjamin, "The Work of Art in the Age of Mechanical Reproduction," in *Illuminations: Essays and Reflections*, trans. Harry Zohn (New York: Schocken Books, 1969), http://web.mit.edu/allanmc/www/benjamin.pdf.

5. Hugo, "Paris," 37.

6. Ibid.

7. Donald Winnicott, "Creativity and Its Origins" (1971), in *Reading Winnicott*, ed. Lesley Caldwell and Angela Joyce (New York: Routledge, 2011), 266.

8. Alfred Whitehead, *Process and Reality* (New York: Free Press, 1979), 21.

9. Hannah Arendt, *The Human Condition* (Chicago: University of Chicago Press, 1998), 186.

6 THE NEW GRAIL

1. Nietzsche, *Daybreak*, trans. by R. J. Hollingdale (Cambridge: Cambridge University Press, 1997), aphorism 550.

2. Antoine de Saint-Exupéry, *The Little Prince*, trans. Katherine Woods (New York: Reynal and Hitchcock, 1943), 46.

3. Internationale Lettriste, *Potlatch*, Bulletin d'information 5, July 20, 1954, http://laboratoireurbanismeinsurrectionnel.blogspot.se/2011/05/internationale-lettriste-et-urbanisme_29.html.

4. Nicolas Sarkozy, "Discours sur le Grand Paris," April 29, 2009.

5. LOI n° 2010-597 du 3 juin 2010 relative au Grand Paris.

6. Constant, "*C'est notre désir qui fait la revolution,*" *Cobra* 4 (1949); translated by Lucy R. Lippard as "Our Own Desires Build the Revolution," in Herschel B. Chipp, ed., *Theories of Modern Art: A Source Book by Artists and Critics* (Berkeley: University of California Press, 1968), 601.

7. Constant, "La liberté ne se manifeste que dans la création ou dans la lutte, qui au fond ont le même but: La réalisation de notre vie," *Cobra* 4 (1949), in *Documents relatifs à la fondation de l'Internationale Situationiste* (Paris: Allia, 1985), 68.

8. Robert de Boron, *Merlin and the Grail: Joseph of Arimathea, Merlin, Perceval: The Trilogy of Arthurian Prose Romances Attributed to Robert de Boron*, trans. Nigel Bryant (Suffolk, UK: Boydell and Brewer, 2005), 54.

7 THE MINT AND THE MUSES

1. See https://www.monnaiedeparis.fr/fr/boutique/monnaies/le-petit-prince
-essentiel-invisible-50eu-or-1-4-oz-be-2015.

2. Louis Massignon, "Voyelles sémitiques et sémantique musicale," in *Le Nouveau Commerce*, cahier 58, 1984.

3. Arthur Rimbaud, *Collected Poems*, trans. Oliver Bernard (London: Penguin, 1962), xxviii.

4. Marcel Mauss, "Catégories collectives et catégories pures" (1934), in *Œuvres*, vol. II (Paris: Editions de Minuit, 1969), 150.

5. Luigi Russolo, *The Art of Noise*, trans. Robert Filliou (New York: Something Else Press, 1967), 11.

6. Ibid.

7. Jacques Cheyronnaud, "Rebuts de sons: 'Bruit' comme terme de critique perceptive," *Ethnographiques*, December 19, 2009, http://www.ethnographiques
.org/2009/Cheyronnaud.

8. Gilles Deleuze, *The Logic of Sense*, trans. Mark Lester with Charles Stivale (London: The Athlone Press, 1990), 179.

9. Luis de Miranda, "Is A New Life Possible: Deleuze and the Lines," *Deleuze Studies* 7, no. 1 (2013): 106–152.

10. Descartes, "La Recherche de la vérité par la lumière naturelle," in *Oeuvres de Descartes*, vol. 11 (Paris: Levrault, 1826), 336; excerpt translated by Michael Wells.

11. Victor Hugo, "Choses vues," in *Œuvres complètes*, volume 2 (Paris: Ollendorf, 1913), 338; excerpt translated by Michael Wells.

12. W. I. Thomas and D. S. Thomas, *The Child in America: Behavior Problems and Programs* (New York: Knopf, 1928), 571–572.

13. Karl Marx, *Economic and Philosophic Manuscripts of 1844*, trans. Martin Milligan (Moscow: Progress Publishers, 1959), 59.

14. G. W. F. Hegel, *Miscellaneous Writings of G. W. F. Hegel*, trans. Jon Stewart (Evanston, IL: Northwestern University Press, 2002), 247.

15. Michel Foucault, *Power/Knowledge: Selected Interviews and Other Writings: 1972–1977*, trans. Colin Gordon, Leo Marshall, John Mepham, and Kate Soper (New York: Pantheon Books, 1980), 153.

8 NEON IN SPACE

1. William Shakespeare, *Julius Caesar*, 2.2.30–31.

2. Honoré de Balzac, *The Girl with the Golden Eyes*, trans. Ellen Marriage, https://www.gutenberg.org/files/1659/1659-h/1659-h.htm.

3. Boschler et al., "Estimation of the Neon/Oxygen Abundance Ratio at the Heliospheric Termination Shock and in the Local Interstellar Medium from IBEX Observations," *Astrophysical Journal*, January 31, 2012, http://iopscience.iop.org/article/10.1088/0067-0049/198/2/13.

4. Whitehead, *Process and Reality*, 47.

5. Jacques Lacan, *L'envers de la psychanalyse* (Paris: Seuil, 1991); translated by R. Grigg as *The Other Side of Psychoanalysis* (New York: Norton, 2007), 66.

6. Ibid, 77.

7. Alexander Roberts and James Donaldson, *The Ante-Nicene Fathers*, vol. 5, trans. John Henry MacMahon (Edinburgh: Presbyterian Publishing House, 1867), https://en.wikisource.org/wiki/Ante-Nicene_Fathers/Volume_V/Hippolytus/The_Refutation_of_All_Heresies/Book_IX/Part_5.

8. Heraclitus, Fragment 18, trans. John Burnet (1912), https://en.wikisource.org/wiki/Fragments_of_Heraclitus.

FINAL CHORDS

1. Pierre Schaeffer, *Traité des objects musicaux* (Paris: Seuil, 1977), 339.

2. Michel Journiac, *Piège pour un voyeur 1969–2011*, YouTube, https://www.youtube.com/watch?v=_YJcJUfwqiE.

3. *Being and Nothingness*, 627; italics in original.

Printed in the United States
by Baker & Taylor Publisher Services